731 Gladstone, M. J.

a Carrot for a nose

D1377086

A gate is a good opener for any discussion, and for centuries gates have inspired unrecognized artists to flights of creative fancy. The maker of this one—a product of the 1870s—is unknown, but it is an acknowledged masterpiece in a New York City museum. The related gate on the next page was very recently photographed by Ann Parker at the entrance of a Vermont barnyard.

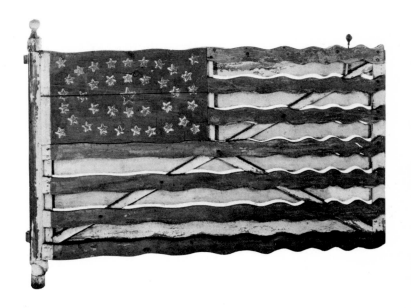

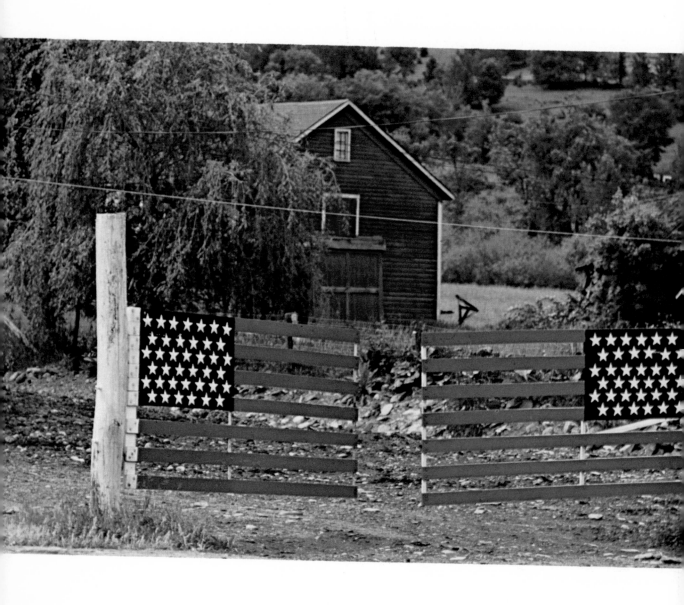

M. J. Gladstone

A Carrot for a Nose

The Form of Folk Sculpture

on America's City Streets

and Country Roads

Charles Scribner's Sons, New York

PICTURE CREDITS. The name of the artist or photographer (and, if necessary, the collection) precedes the source of each illustration. A great number of illustrations are from the Index of American Design at the National Gallery of Art and the Farm Security Administration file at the Library of Congress. These are identified respectively as IAD and FSA. The initials MJG identify the author.

Page 1 Museum of American Folk Art, New York City; 2 Ann Parker; 7 Ann Parker; 9 Edward DiGennero, IAD; 10 MJG; 11 *both photographs* MJG; 12 *top left* Lloyd Broome, IAD, *bottom left* Marian Page, IAD, *right* Robert Barton, IAD; 13 John Collier, FSA; 14-15 *all photographs* MJG; 16 Museum of American Folk Art; 17 *top* Henry Tomaszewski, IAD, *left* David Ramage, IAD, *right* Robert Pohle, IAD; 18 Charles Gladstone; 19 Frances Cohen, IAD; 20 William Penn Memorial Museum, Harrisburg, Pa.; 21 Frances McLaughlin-Gill, Collection of Donald Forst and Gael Greene, photograph courtesy of Museum of American Folk Art, New York City; 22 *upper left, both photographs* Nina Howell Starr, *bottom* Division of Graphic Arts, Smithsonian Institution, Washington, D.C.; 23 *top* Collection of Herbert W. Hemphill, Jr., *bottom* Michael Hall-Carl Toth, Collection of Mr. and Mrs. Michael D. Hall; 24 *all photographs* Mark Feldstein; 26 *top* The Metropolitan Museum of Art (Elisha Whittelsey Collection, 1961), New York City, *middle and bottom* The New-York Historical Society, New York City; 27-28 *all rubbings* Ann Parker and Avon Neal; 29 *all photographs* Mark Feldstein; 30 Carl Mydans, FSA; 31 Dorothy Hay, IAD; 32 Albert Ryder, IAD; 34 *top left* Albert Ryder, IAD, *bottom left* Dorothy Handy, IAD, *right* Russell Lee, FSA; 35 *left* Ben Shahn, FSA, *top right* Paul Poffinbarger, IAD, *bottom right* MJG; 36 John Vachon, FSA; 37 *top left and middle* Russell Lee, FSA, *top right* John Vachon, FSA, *bottom, all photographs* Russell Lee, FSA; 38 *left* Mark Feldstein, *middle* MJG, *right* Emily Wasserman; 39 *top* Jack Delano, FSA, *bottom left* Michael Philip Manheim, *bottom right* MJG; 40 Nina Howell Starr; 41 Collection of Mr. and Mrs. Eugene Cooper, photograph courtesy of Gerald Kornblau; 42 MJG; 43 *all photographs* MJG; 44 Allan Ludwig, IAD; 45-48 *all rubbings* Ann Parker and Avon Neal; 49 *all photographs* Allan Ludwig, IAD; 50 *top* Christ Makrenos, IAD, *middle* Max Fernekes, IAD, *bottom* John Sullivan, IAD; 51 Library of Congress, Washington, D.C.; 52 Lawrence Flynn, IAD; 53 Roberta Spicer, IAD; 54 MJG; 55 New York Public Library (Picture Collection), New York City; 56 Russell Lee, FSA; 57 *top* John Sullivan, IAD, *bottom* Henry Tomaszewski, IAD; 58 *top* Henry Tomaszewski, IAD, *bottom* Donald L. Donovan, IAD; 59 *top* Dorothy Handy, IAD, *bottom* Michael Riccitelli, IAD; 60 Henry Murphy, IAD; 61 Ernest A. Towers, Jr., IAD; 62 *both photographs* MJG; 63 *all photographs* MJG; 64 Library of Congress, Washington, D.C.; 65 New York Public Library (Picture Collection), New York City; 66 John Vachon, FSA; 67 *both photographs* MJG; 68 *top* Dorothea Lange, FSA, *bottom* Russell Lee, FSA; 69 John Vachon, FSA; 70 New York Public Library, N.Y.C.; 71 Ann Parker; 72 Jack Delano, FSA. Words and music for *Frosty, the Snow Man*, referred to on page 7, are by Steve Nelson and Jack Rollins, copyright Hill and Range Songs, Inc.

Contents

ACKNOWLEDGMENTS

I am indebted either personally or through their published work to many artists and folk art specialists who have done pioneer research on the subjects this book highlights. In particular, I have been helped or guided by Ken Fitzgerald, author of *Weathervanes and Whirligigs* (Clarkson N. Potter); Mark Feldstein, Ann Parker, and Avon Neal in connection with pavement lids; Frederick Fried, author of *Artists in Wood* (Clarkson N. Potter), in connection with show figures; Nina Howell Starr, Emily Wasserman, and Mark Feldstein in connection with modern trade signs; Rudi Stern in connection with neon; Allan Ludwig, author of *Graven Images* (Wesleyan University Press), Emily Wasserman, author of *Gravestone Designs* (Dover Publications), and Ann Parker and Avon Neal in connection with gravestones; Adele Earnest, author of *The Art of the Decoy* (Clarkson N. Potter); the late William J. Mackey, Jr., author of *American Bird Decoys* (Bonanza Books); Frederick Fried, author of *A Pictorial History of the Carousel* (Bonanza Books); and Ann Parker and Avon Neal, respectively author and photographer of *Ephemeral Folk Figures* (Clarkson N. Potter), in connection with scarecrows and snowmen. I am very grateful for the good-natured instruction and assistance of Lina Steele at the Index of American Design. Most of all, I am indebted to Herbert W. Hemphill, Jr. for leading me to a living folk art and to Mary Black for showing me how to put it in order.

Introduction

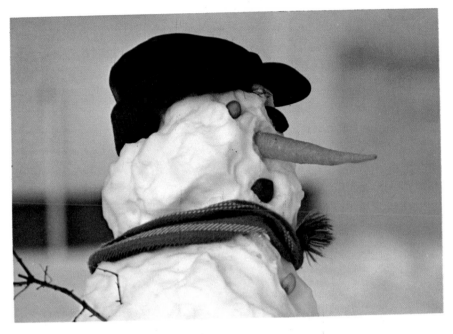

The carrot nose of this rather crudely modeled figure apparently pointed the way to other kitchen improvisations in the way of prunes and nuts that serve as facial features and buttons. The earwarmers, the tightly knotted scarf, and even the blustery expression suggest that this is one snowman who came into being on a really chilly day—and maybe haste is the explanation for the use of one prune for an eye and the other for a mouth. The details are improvised and the construction slapdash, but this is an undeniably colorful and shapely interpretation of a traditional form.

There is only about one-fifth of the United States that does not have regular snowfalls, so like most Americans I have lived most of my life with snow as part of the winter landscape. Yet for me the first heavy snowfall of the season continues to rank as one of the year's real events. As long as I can remember, it has held the promise of that still morning after the storm when, like Whittier, I could look upon "a world unknown."

On those clear, sunny mornings when the earth has been purified and renewed I can use the snow itself to make a first inhabitant; and, like God creating Adam, I make him in my own image. I give him a head and I mark off his upper torso. I try to provide him with some natural features—eyes, a nose, a mouth, perhaps a suggestion of arms. Since 1950 I have had the benefit of a song called *Frosty, the Snow Man* to remind me of most of the details.

As the years pass a few adjustments are necessary. Where it can be found, the stovepipe hat that capped the snowman of my youth is now venerated as a rare antique. In some places the lumps of

7

coal once taken for granted as eyes may be even rarer. The basic snowman is unchanged—a mound of snow topped with a big snowball chest which, in turn, is topped with a smaller snowball head. But new forms have taken the place of the details once easily collected from cellars and attics when twigs and stones were buried from sight. A single snowman feature has survived from an epic past. The source is not always the root cellar now—more likely it is a plastic bag in a refrigerator—but any sculptor who wants can still supply his snowman with a carrot for a nose.

Snowmen have not often been looked at as sculpture but there is no good reason why they should not be. They are modeled and sometimes even carved like clay or stone statues. Their makers, who have definite ideas of what they want to make, use technical knowledge and imagination as they go about the making. And of course we are free to judge the end product on artistic grounds —which is exactly what we are doing when we recall the superiority of our own work three years back or allow that the snowman down the road is better than ours.

This book is concerned with forms like snowmen that you might come across on streets or roads in many different parts of the United States. Most of these folk forms last a good deal longer than snowmen, and some of them—like weathervanes or trade signs—are older than the nation. Although like snowmen they were modeled or carved according to a plan that met artistic standards, their makers seldom thought of themselves as artists. The world for which they were made usually thought of them as utilitarian objects—scarecrows that kept birds away, decoys that brought them near—or as decorative forms that were unworthy of serious consideration.

As their age and rarity advanced, some such folk objects found their way into museums, however. Generations for whom their original use had no significance looked at them there in the same way they might look at ancient statues or carvings from Gothic churches. They thought of who might have made them. They wondered why their makers made them in the particular way they did. Examining them in combination with similar things, they saw that some were better than others; and thinking of them

in relation to sculpture of other times and places, they recognized the best of them as very good art indeed.

Most folk sculpture is not in museums, though. Some of it, like the snowman, is ephemeral—vanishing when its work is done. Hardy examples, however, including works of considerable age, continue in active use. Most streets and highways offer any number of folk figures to anyone who cares to see them. Ponds and pavement blocks, church spires and cornices harbor forms that speak for their makers' skill and imagination and reveal small and real details about the time they were made. As you look for them, and learn to see their differences and the meaning of their differences, you are likely to think of all outdoors as a museum. You can start by thinking of why the snowman with a carrot for a nose has an aluminum chicken-pie plate for a hat—and end up with an aesthetic experience.

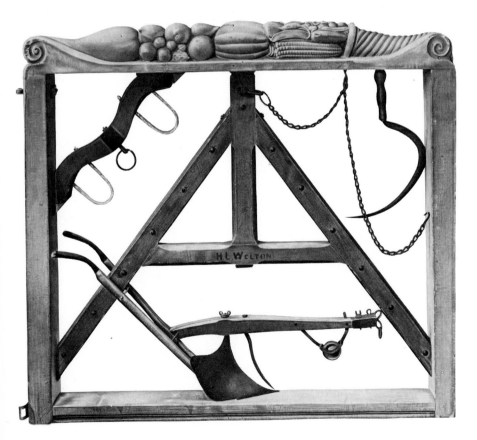

This gate, sent to Expo '70 in Tokyo by the U.S. government as an outstanding expression of our native art, stood for over fifty years in Waterbury, Conn., before the doorstep of its maker, Hobart Victory Welton—farmer, engineer, town selectman, state legislator, and for twenty-five years Waterbury's superintendent of highways. His father's death when he was fourteen barred Welton from a career as an artist, but he whittled and chiseled throughout a life that spanned the greater part of the nineteenth century. Some of the embellishments of his homestead—like the top of this gate—look at first like conventional decorative sculpture. But the homely implements below—precisely scaled and carefully composed—establish Welton's gate as a completely original celebration of the bountiful mid-century farming that afforded him the comforts of life.

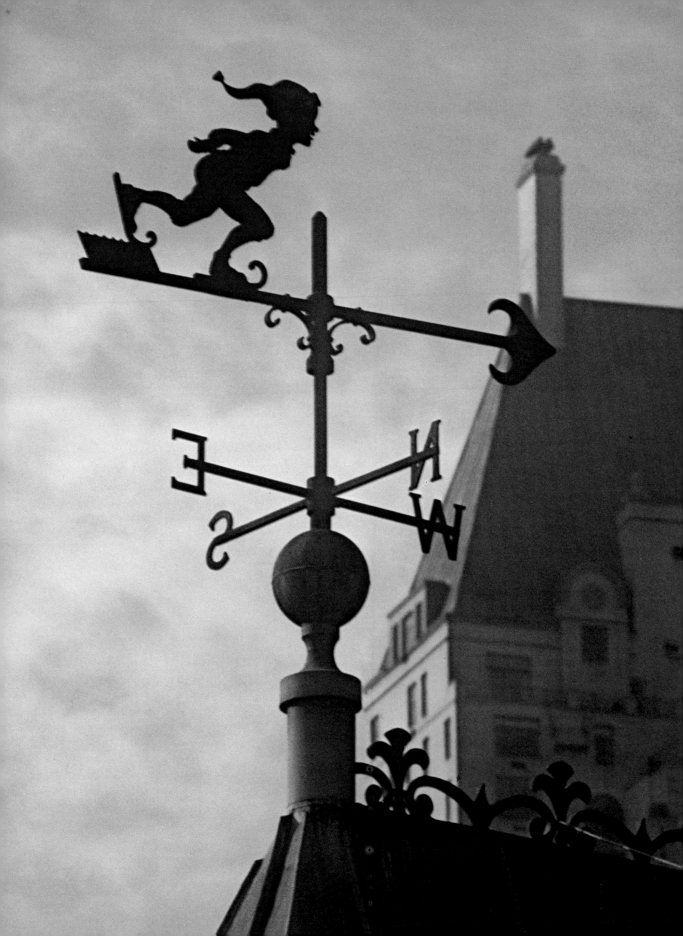

Weathervanes

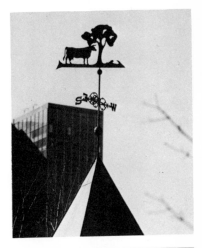

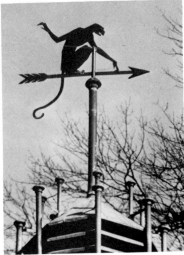

Europeans have been using pivoting wind indicators for at least two thousand years, and Americans have had weathervanes for well over three hundred. When the nation's prosperity depended on sailing ships and crops, shifts in the wind were matters of continuous importance, and all eyes made regular checks of the local church steeple to know if the wind promised fair weather or rain. Most weathervanes, however, are much closer to the ground than those on church steeples. Since a pivotal wind indicator should be fifty or sixty feet above its surroundings to give a true indication of the wind's direction, their presence probably has more to do with ornament than with accurate weather forecasting.

The shapes of early American weathervanes followed European models. The Vikings had quadrant-shaped metal vanes mounted on the masts of their ships, and throughout Europe forts and castles supported pierced metal vanes that looked like banners or armorial bearings. America's very first weathervanes were probably on churches, though, and many of them were shaped like roosters. Centuries before, a pope had decreed that church spires should terminate with a cock's figure to remind the wayward of Christ's warning after the Last Supper—that Peter would deny knowing him before the cock crowed twice. In England, the word "weathercock" seems to have been in use much longer than the word "weathervane," and the rooster probably figured as the most common English church vane until the Great London Fire of 1666 gave Sir Christopher Wren the opportunity to establish a new weathervane model for the many church spires he was

City weathervanes are not uncommon sights, rising above tall church steeples but just as often decorating and identifying retail stores and other low buildings. Like the ice skater opposite, these two vanes are in New York City's Central Park. The cow surmounts the cupola of a nineteenth-century stone structure planned as a dairy; the monkey, a WPA production of Hunt Diederich, marks a popular modern building at the zoo.

The compass points are identified beneath the lively skating figure opposite at Central Park's Wollman Rink, but he is much too close to the ground to serve as a dependable wind indicator.

11

called upon to re-create. America's churches soon imitated Wren's graceful spires, including the decorative gilded bannerets that surmounted them. For the two centuries that followed, the great number of American church weathervanes were variations on the pattern he established—with an arrowlike tip followed by a broad flat body cut to suggest a forked banner or pierced and molded in a variety of heraldic and geometric designs.

For the most part the men who made the early weathervanes are anonymous. Since many vanes are made of metal, some of their makers must have been local blacksmiths or tinsmiths working with wrought iron or sheet metal that was handled flat or molded over a wooden form to produce a rounded figure. Wooden vanes might be made by local carpenters or whittled by less professional hands. Whether round or flat, the aim was usually to produce a distinctive silhouette in a size that would be meaningful at a considerable distance from ground level. Many of the vanes that appear tiny above churchtops are actually as big or bigger than we are. Some arrowlike weathervanes are more than ten feet long.

The vanes shown on these two pages suggest something of the range of size and shape produced in wood. The whale is only twelve inches long and the horse about thirty. The bold arrow opposite, photographed by John Collier on an Elmira, N.Y., barn, is considerably larger.

The serpent weathervane, drawn for the Index of American Design by Lloyd Broome, strikes a patriotic note ("Don't Tread on Me"), and the Nantucket whale, drawn by Marian Page, speaks for local industry. It was the horse, however, which was almost universally the most popular weathervane subject. This pensive Rhode Island example of about 1870 was drawn by Robert Barton.

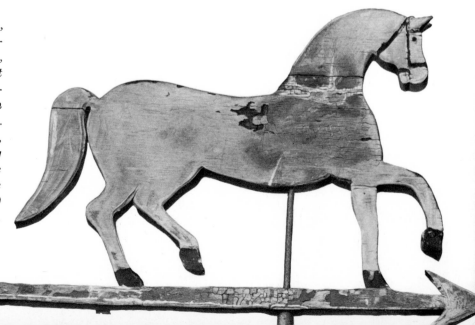

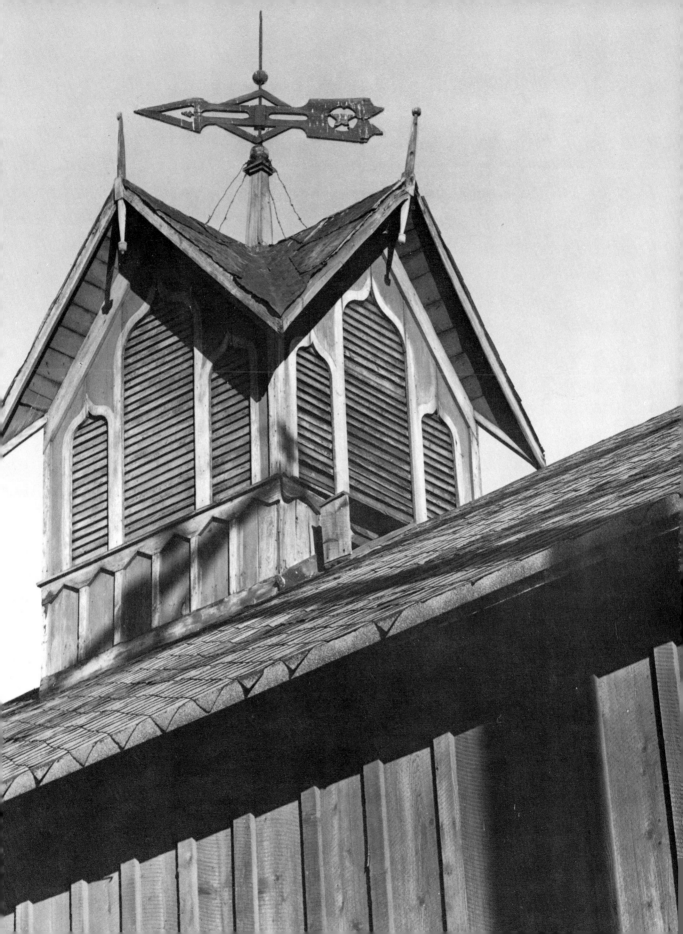

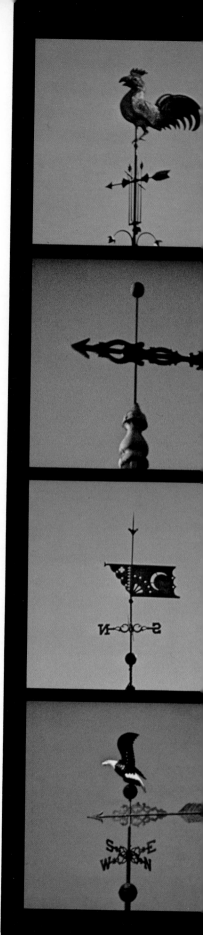

Photographed against skies that signify all sorts of weather, these sixteen weathervanes only begin to suggest the range of material, size, and design of types now in service. The upper eight are all church vanes, starting at top left with the earliest—the monster rooster that Shem Drowne of Kittery, Me., created for the spire of a Boston church in 1721. Over five feet high and weighing more than 170 pounds despite its hollow copper construction, Drowne's rooster has long outlived the building for which it was made. In 1873 it was acquired by the First Church in Cambridge, Mass., above which it still soars today.

To its right are three decreasingly bannerlike vanes of later date; a bold and simple one at the Exeter, N.H., Congregational Church; a delicate example of the 1820s from the Sharon, Conn., First Congregational Church; and one with a glittering cometlike sphere at the First Parish Church in Bernardston, Mass.

In the second row are a sizable, shaped wooden vane of the early nineteenth century at the Brunswick, Me., Methodist Church; a Vermont example, from the Perkinsville Community Church—with a palm-leaf tail based on a design that Asher Benjamin published in one of his popular nineteenth-century building handbooks; a stubby, flat one terminating in a star at the Stratham, N.H., Community Church; and finally another early rooster, this one a 1729 figure on the spire of the First Church of Deerfield, Mass.

Below these are weathervanes representing a variety of nonreligious tastes and interests—starting with a Gothic Revival banner that rises fashionably above the barn of the Walnut Grove Poultry Farm of Vernon, Vt. (replacing the more predictable gilded fowl). To its right are an animated wrought-iron horse with a far-flung counterbalance from Belmont, N.Y.; a popular nineteenth-century commercial form from the Deerfield, Mass., Memorial Hall, in which a pointing hand replaces the more common arrow tip; and a dashing hose cart above the cupola of the Deerfield fire station.

In the bottom row are the huge polychromed eagle vane of the Owego, N.Y., firehouse; an unusual nineteenth-century cogwheel design from a textile mill (now occupied by the Galland Co.) in Newmarket, N.H.; a modern silhouette of a vintage roadster at the Marc R. Buick-Pontiac showroom in Easthampton, L.I.; and, finally, one of the most familiar of all American weathervanes—this one photographed at Hartford, Conn.

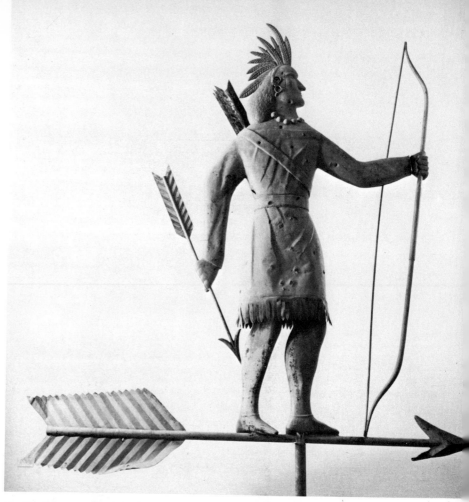

St. Tammany was the symbol of a nineteenth-century fraternal organization known as the Improved Order of Redmen, dedicated to honor and truth, and incorporating animal totems of the woodland tribes into its ritual. This huge weathervane representing St. Tammany was erected above the building of the East Branch, N.Y., chapter of the Order in the last years of the century. Made of hollow copper sheeting, and measuring more than nine feet in both height and width, it is probably the largest of all American weathervanes. In 1963 it was acquired for the collection of the Museum of American Folk Art in New York City.

The three metal figures opposite, reproduced from drawings in the Index of American Design, are all of much smaller size. The patriotic figure of Columbia, drawn by David Ramage, was made after 1885 by the Boston firm of Cushing and White. The game cock, drawn by Robert Pohle, and the fish, drawn by Henry Tomaszewski, are from about the same period.

The heyday of American weathervanes was the nineteenth century, when prospering farm life produced a wide range of decorative forms that celebrated all the diversity of life around them. Horses and cows capped innumerable barns and stables, as did chickens and sheep of every conceivable variety. Fish, whales, and sailing ships appeared in abundance along the seacoast. Wheeled vehicles—carriages, sulkies, and, later, even locomotives —were popular forms everywhere. Indian archers, trumpeting angels, and the national eagle crowned public buildings and private homes throughout the land.

Many of the most ingenious examples are homemade forms fashioned from flat boards, but most of the late nineteenth-century weathervanes are hollow figures, mass-produced in molded sheet metal that was likely to be gilded. Today, some of the same weathervane forms—running horses and soaring eagles in particular—continue to be manufactured by the firm of J. W. Fiske in Paterson, N.J.

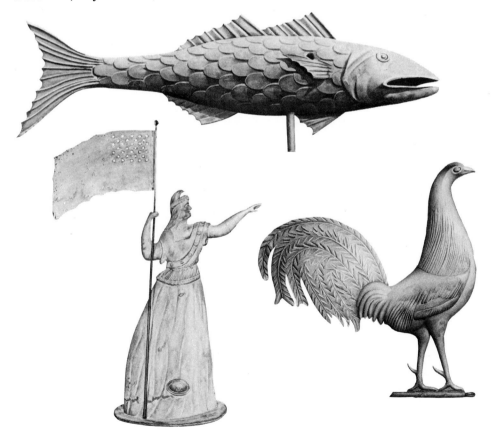

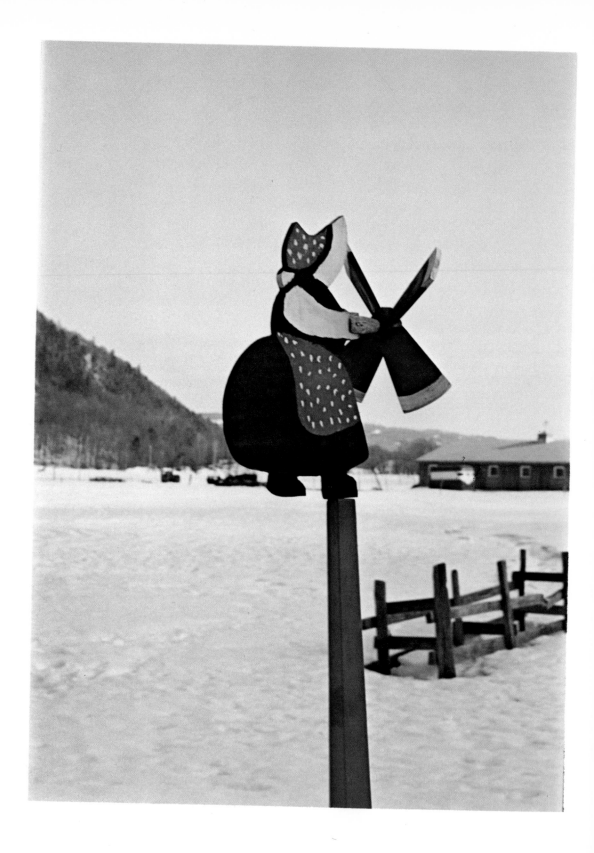

Whirligigs

In northern Europe, the flailing arms of the windmill have been a source of power since the twelfth century. Europeans have probably been making related toys with wind-driven revolving blades for almost as long. The modern Celluloid pinwheel, for example, has been traced back to miniature wooden windmills that were popular among sixteenth-century children.

Just when or where the making of doll-like figures with wind-driven flailing arms first occurred is unknown. Nor do we have any exact information about the appearance of those propeller-activated milkmaids and sawyers that are now a standard part of the American roadside souvenir stand display. Both of these wind toys as well as miniature windmills and wooden birds with wind-propelled wings are known today as whirligigs, but while the word is an old one its use in this connection is relatively new. To begin with, the word *whirligig* seems to have been applied to the carousel; until well into our own century the word for what we now call whirligigs seems to have been *weathervane*.

The windmill is still a popular model for wooden wind toys, and so is the traditionally dressed Dutch girl who pivots with the wind to put a set of blades in spinning motion. The lady at the left, photographed very recently in South Woodstock, Vt., harks back to toys of the sixteenth century, but she is also the direct American descendant of the sailor at the right. This early nineteenth-century figure, drawn by Frances Cohen for the Index of American Design, sports a hat which suggests an officer in the War of 1812. The skillfully opposed angles of his arms suggest a carver—possibly himself a sailor—who knew how to get the most out of every gust of wind.

One way of dating whirligigs is through the costumes of figures they depict. Since the oldest costumes worn by whirligig figures found in the United States are the uniforms of Hessian soldiers, it has been suggested that we owe the whirligig to German mercenaries who fought in the Revolutionary War. However, almost all early American whirligigs depict soldiers or sailors. Probably made as boys' toys, they may simply have been based on military models to differentiate them from dolls that were intended for girls. Since any figure with flailing arms has an unavoidably comic aspect, early nineteenth-century American woodcarvers were undoubtedly predisposed to use whirligigs to caricature pompous generals or martinet lieutenants or, above all, the well-drilled, nattily uniformed, and recently vanquished national enemy.

The great number of simple wooden whirligigs which depend on opposed arms for their action seem to have been made before the Civil War. Like dolls of the period they were of interest more for the figures they depicted than for what they could do. Just as simple dolls continued to be made in decreasing numbers into the late nineteenth and twentieth centuries, occasional whirligigs were carved to depict Union or Confederate soldiers. Others represent baseball players and policemen, whose typical actions are so closely akin to windmill movement.

The inventive ingenuity of the later nineteenth century produced an altogether different kind of whirligig in which one or more figures performed complicated movements. The action depended on wind power but often involved a multi-vane propeller and cranks and gears for transmission. The materials included sheet metal and iron rods as well as wood. The manufacturing technique was no longer whittling but mechanical assembly.

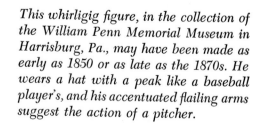

This whirligig figure, in the collection of the William Penn Memorial Museum in Harrisburg, Pa., may have been made as early as 1850 or as late as the 1870s. He wears a hat with a peak like a baseball player's, and his accentuated flailing arms suggest the action of a pitcher.

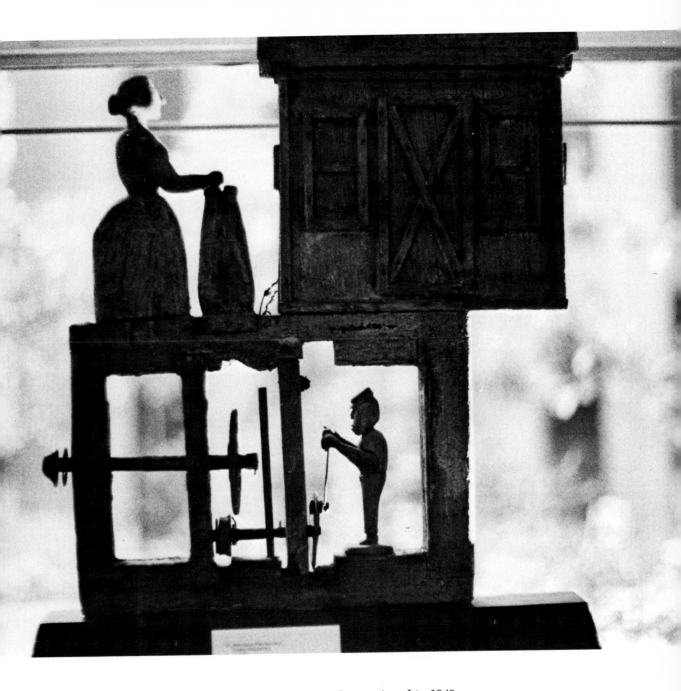

Although several of its parts are missing, Home Industry *(as this 1840s whirligig is known) points the way to the multiple-action wind toys of the late nineteenth century. Here, one propeller apparently set in action both the man laboring below-stairs and the statuesque woman churning in her dooryard, but the net effect was probably that of relayed activity. Now in a private collection, this whirligig was included in the U.S. art display at Expo '70.*

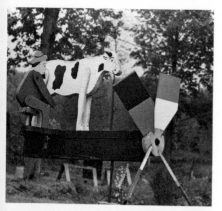

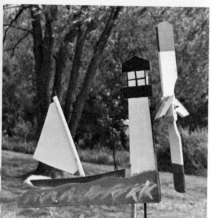

The activity depicted in these later whirligigs was usually related to common household chores—chopping wood, milking cows, churning butter, scrubbing laundry—or to amusements like see-sawing, dancing, and music-making. Some of them even depict carousels. Like the wooden soldiers of an earlier period they are comic toys, but the joke depends on invisible power rather than on uncontrolled action. The best of them involve a series of activities the last of which is far removed from the propeller that generates it. Like Rube Goldberg's cartoons they are the outcome of an era when men were still doubtful about how much labor and action could be safely transferred to machines.

In a very much simplified way this is the whirligig that remains with us. Whereas the contemporary simple-action version is likely to be based on a standard pattern, however, its prototype depended on each maker's sense of fantasy, and the complexity of action was the expression of his mechanical ingenuity. What is most revealing about the historic background of the cottage industry whirligigs you can find along the roadside today is that as often as not they continue to depict chores and activities that have all but vanished from the modern world.

Nina Howell Starr photographed the whirligigs at the left in 1973—both the work of Tony Seliskey of Keene, N.H., who refers to them as "wind-mills." In one case the wind-driven propeller generates the alternating arm motion of the milkman; in the other it causes the little dinghy to bounce over the waves. In Rube Goldberg's drawing below, a weather force generates a much more complicated chain of fifteen actions—in the name of "scientific" information observable all the while through the window.

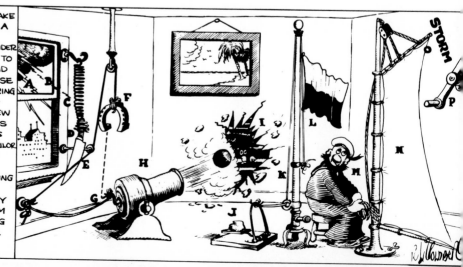

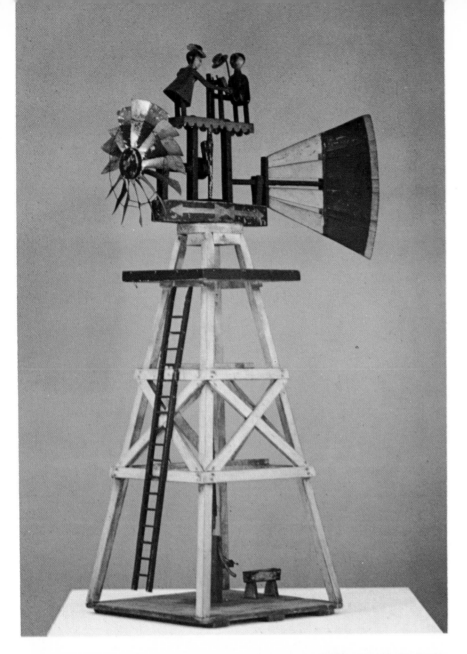

Both of these sizable whirligigs of the early twentieth century are in private folk art collections. There is something preposterous in the relationship between cause and effect in each of them. The upper one depends on a mechanism that might set a dirigible in motion to activate two figures who alternately bow to each other. As a final touch of surrealistic ridiculousness, the scaffolding that raises the contraption three feet above its base is furnished with a ladder.

The complicated lower example from Gap, Pa., measures a full 7½ feet from end to end and depends on three propellers for a succession of five different seesaw or revolving actions.

THE SPORT WORLD

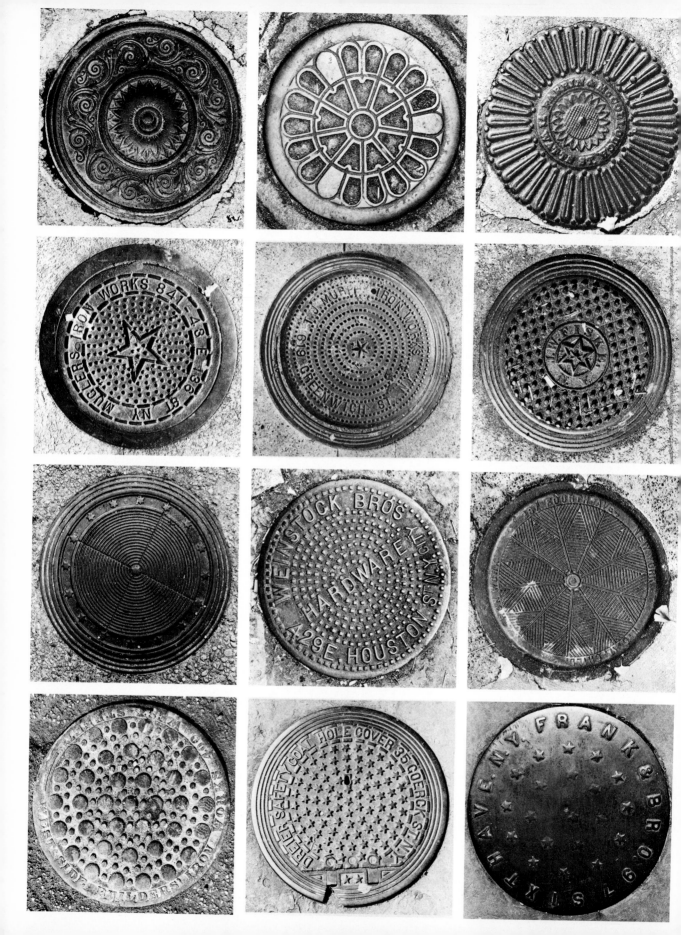

Pavement Lids

American ironworks have been operating since 1619, and by the later seventeenth century iron pots and iron firebacks were being produced here at several locations. Unlike the wrought iron that was worked by the blacksmith, the cast iron pieces were extremely brittle. Perhaps because of this, the sand molds in which they were cast often incorporated low-relief designs which could deflect sharp blows against an otherwise flat and vulnerable iron surface.

Throughout the eighteenth century most of America's cast iron had to do with cooking and heating. In addition to kettles and griddles and grills, the ironworks produced andirons and firebacks and, finally, stoves. The surface decorations of these last two items became increasingly elaborate as the century progressed, and by the nineteenth century the popularity of cast iron depended just as much on its decorative possibilities as on its utilitarian value. Cast iron hitching posts were shaped like anything from balusters to jockeys; cast iron deer and dogs gave a parklike atmosphere to residential lawns; cast iron fences and gates and balconies and roof crestings embellished buildings of every description. Iron foundries throughout the country offered their wares to builders in a variety of ornamental designs that will probably never again be equaled.

Nevertheless, the exuberant catalogs that the later nineteenth-century ironworks published continued to include some of the old utilitarian objects and some new utilitarian forms appeared as well. Among the latter are the round iron plates that were made to seal off openings in the city's streets.

These twelve photographs by Mark Feldstein reveal the variety of New York City coal vault covers in place today, with the oldest examples uppermost. In the second row are later nineteenth-century covers advertising the ironworks that produced them; in the third, a still later one advertises a retail store rather than a maker. Immediately below it a patented safety cover points to increasingly specialized production of an important element of the New York City street scene.

25

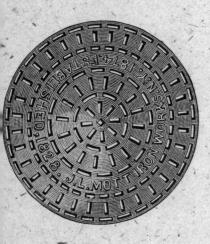

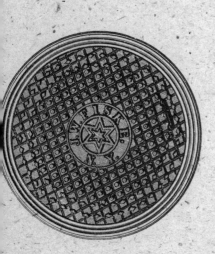

It is difficult to say what sort of openings came first. Fuel delivery and storage, which emerged as a general urban problem as the coal stove replaced the open wood-burning hearth for cooking and heating, may have pointed the way. Unlike wood, coal was dirty stuff to handle, and the cellar vaults in which it was stored had to be replenished regularly. To keep coal dust at a minimum above cellar level, home owners cut delivery openings from the street to their storage vaults and fitted them with lids that could be readily opened for each new supply of fuel. Cast iron was the perfect material for the lid, of course—durable and strong enough to support the weight of a pedestrian. The decorated surfaces of coal-vault covers may have been initially intended to deflect sharp blows, but they also helped to prevent slipping in wet or snowy weather.

To begin with, coal-vault covers were probably developed for the fastidious and the rich, but with the advent of central heating and the construction of tenements and apartment houses, coal chutes from street to storage vault became standardized, and the sidewalk pavements of city streets with late nineteenth- and early twentieth-century apartment buildings are liberally sprinkled with them. The earliest examples—small and intricately worked— gave way to somewhat larger lids which characteristically advertise the foundry that produced them. Each foundry developed house designs for coal-vault lids; several patented exterior lock devices and hinge arrangements which triggered side rails that blocked the absent-minded passerby from a tragic step.

Almost simultaneously with the rise of coal as a domestic fuel and the development of the residential coal vault, cities as a whole went underground to meet more general needs. The first of these was a water supply, the second sewage disposal. In the last half of the nineteenth century virtually every American city of size and activity provided itself with a network of conduits beneath its streets for incoming water and outgoing waste. In time the network expanded to include electric cables, gas mains, and telephone lines. All of these subterranean passages required regular access. Obstructions in water and sewer lines were inevitable; cables required repairs, telephone lines inestimable additions.

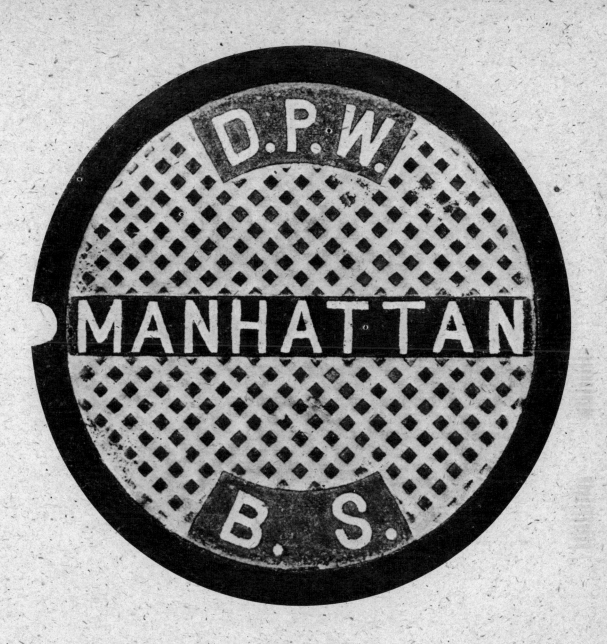

The three woodcuts on the facing page, all from manufacturers' catalogs,
document developments in the evolution of pavement lids. Uppermost is a
Boston maker's 1859 design for a coal vault lid that protects the passerby.
Below it is a major New York foundry's 1874 design "made especially to
prevent slipping." The J. W. Fiske lid of 1921 looked toward wider horizons
as U.S. city populations swelled. The maker boasted that its lids conformed
to the requirements of the Department of Public Works of New York City
and offered "the name of any town or city . . . cast on cover." The lid above
was designed for the New York City Bureau of Sewers. Like those on the
following page, it is from a rubbing by Ann Parker and Avon Neal.

The designs and initials on manhole covers record the development of community services and mark the rise and fall of the corporations and municipal departments concerned with them. The square New York City cover above was made for the Consolidated Telegraph and Electrical Subway Company—a corporation later absorbed by Con Edison, whose distinctive "bicycle chain" lid is shown below. The telegram is no longer a significant part of city life, but the growing importance and complexity of the subway system ultimately brought the efforts of many independent corporations under the unified control of the New York City Transit Authority.

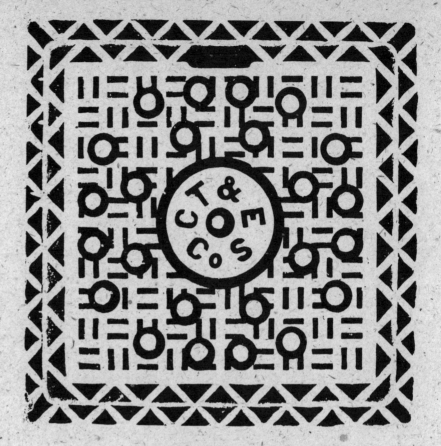

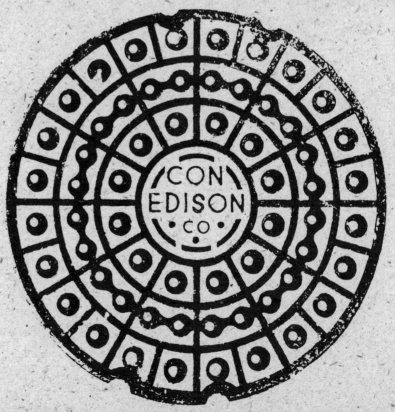

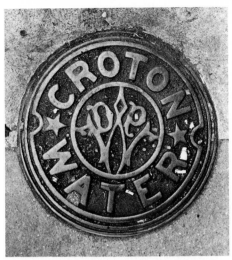

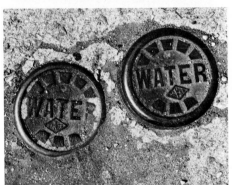

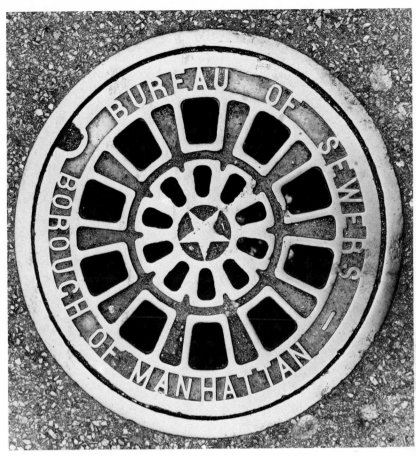

Water supply and sewage disposal systems are a modern city's lifeline. Here is formal evidence of their existence, on which New Yorkers tread daily.

The solution to these needs was the manhole—or rather, a whole system of manholes large enough to allow a repairman to approach problem areas from street level. The ironworks rose to meet the need with round and square lids strong enough to support not only a pedestrian but vehicular traffic as well. The surface textures they provided for these road covers were big and bold; while early examples advertise the maker, later ones identify the service involved by name, initials, insignia, or pattern. Most underground urban utilities had their start under private auspices but many were subsequently adopted as municipal responsibilities. The names, initials, and symbols on manhole covers can tell anyone who cares to read them the story of how urban services were developed.

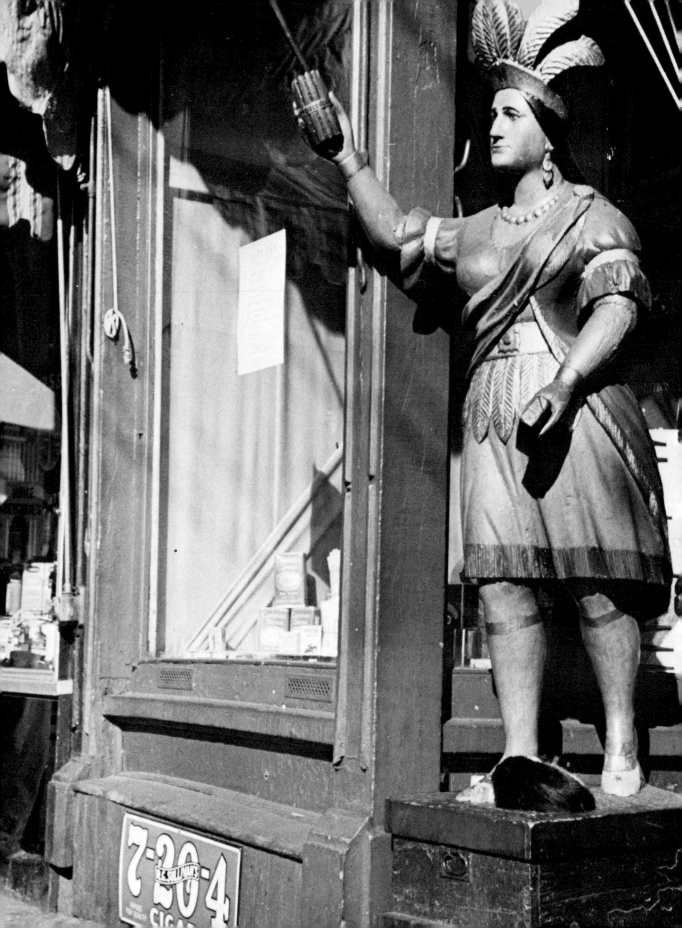

Trade Signs

It has been estimated that during the last part of the nineteenth century more than five thousand merchants in New York City alone were using life-size Indians or other carved symbolic signs to identify their business establishments. Most of these figures have long since disappeared, but a close look at most cities' commercial streets and a good many inter-city highways reveals that the representational trade sign is far from gone and that a great number of contemporary examples have deep roots in the past. Barbers continue to identify themselves with striped poles; locksmiths advertise their work with giant keys and watchmakers with clockworkless clocks. A few cigar-store Indians survive, too, but most of the oldest working examples are no longer stationed before tobacconists. They are more likely to appear before restaurants and motels with Indian names or emporiums that specialize in candy and ice cream and other vestiges of a Victorian past. Until recently, one was attracting attention to a fashionable children's barber shop on a major New York City thoroughfare.

Indians first saw service as tobacconists' symbols in early seventeenth-century England—little more than fifty years after smoking had been introduced from the New World. As the original supplier of the tobacco plant, which was almost simultaneously praised as a magic cure for countless diseases and damned (by King James I, among others) as "harmful to the brain, and dangerous to the lungs," the native American was a logical symbolic choice. Outside of feathered headdresses, however, the early English figures look more like miniature black slave boys than like the men they supposedly represented.

The figure on the facing page was still serving as a Manchester, N.H., tobacconist's sign in 1936, when Carl Mydans photographed it for the Farm Security Administration file. The one above had been retired from active service at about the same time, when Dorothy Hay recorded it for the Index of American Design. Both purport to be Indians, but in their posture, dress, and substantial proportions, they are closer to the spirit of a mid-nineteenth-century opera singer. The especially graceful figure above, relieved of the customary snuff box and bundle of cigars, might well be at the high point of a memorable aria.

31

In America, it was almost another century before tobacconists took up the symbolic Indian figure. Although American wood-carvers had an ample supply of live Indian models to guide them, the figures they produced were essentially the same as those made in England. From the very outset, therefore, the American cigar-store Indian had little to do with reality. As the nineteenth century progressed, American carvers produced a range of increasingly elaborate and dramatic figures for tobacco merchants. They soon abandoned the slave-boy features of the earliest examples, but in all other respects the fanciful interpretation of Indian appearance was an unchanging part of their working tradition.

The enormous number of wooden figures carved for American tobacconists tells us a good deal about nineteenth-century smoking habits. To begin with, however, the volume of production may have been as much due to the availability of woodcarvers as to the demand. During the 1840s, when American shipbuilding developed as a major national industry, shipcarvers had been trained to meet an ever-increasing demand for their skills. In Boston, Baltimore, Philadelphia, Bath, and—above all—in New York City, carvers supplied decorative work for the huge clipper ships that were the glory of their age. Their work was dramatically interrupted in 1856 by an economic depression which dealt a blow to all American productivity. The Civil War, which rectified a general picture of unemployment in the United States, had little to offer the shipcarvers, whose work was essentially a luxury product. The war ultimately dealt them a final blow by establishing the superiority of the ironclad ship. As wooden vessels gave way to iron ones, the shipcarvers were forced to look elsewhere for work. They found their salvation in the burgeoning retail tobacco business, and wooden Indians marched across the land.

Two extremes of inventive fancy are represented by these tobacconists' symbols that were popular alternatives to the traditional Indian. The elegant "Captain Jinks" at the left, possibly first conceived as a caricature of wood-carver Samuel A. Robb, was in a private Rhode Island collection when Albert Ryder recorded it in the late 1930s for the Index of American Design. The huge and sinister Punch opposite was then still "on the job" in Iowa.

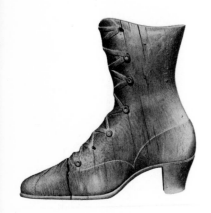

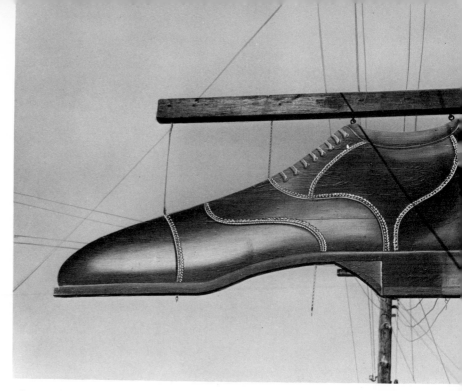

The carved bootmakers' signs at the left record footwear of the late nineteenth century. The high-heeled lady's shoe was drawn for the Index of American Design by Albert Ryder, the buttoned one below by Dorothy Handy. The giant painted representation of a popular man's shoe of the twentieth century was hanging outside a shoe repair shop in Jeanerette, La., when Russell Lee photographed it in 1938.

Before long, some of the carvers marched with them, and figures were produced in Detroit and Ashland, Wis., as well as in the coastal cities of Philadelphia, Baltimore, Washington, D.C., Providence, and Gloucester. The national center of production was New York City, however, headquarters of William Demuth, who supplied over thirty different models of "show figures" to tobacconists throughout the country. New York was also the location of the workshops of such accomplished carvers as John Cromwell, Charles Dodge, Thomas Brooks, and—the giant of American commercial woodcarving—Samuel Anderson Robb. The figures executed for tobacconists included Scotsmen, Turks, Punches, Dandies, and Ladies of Fashion as well as Indians in a wide variety of costumes and poses. The same figures and some others saw service with clothiers, breweries, tea stores, theatres, banks, and insurance houses. As the century progressed, Demuth offered them cast in zinc for greater durability, and other

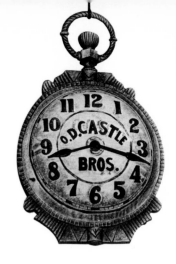

suppliers produced them in cast iron. It is a mystery that, despite their numerousness and the strength of at least some examples, fewer than four hundred are known to survive today.

The cigar-store Indian that captured the national imagination in the late nineteenth century was actually a new manifestation in a long tradition of carved and painted trade signs. In part the signs owed their existence to general illiteracy—they advertised the availability of goods and services to those who had never learned to read. They also served to pinpoint the location of particular business establishments before the institution of house numbers. In a street where two bootmakers competed, one might display a lady's shoe as his symbol, the other a riding boot. If there was no symbolic variety available to the competitors, they might

Clocks have a long history as trade signs—but their symbolism is not altogether constant. The one below, photographed by Ben Shahn outside a Plain City, Ohio, repair shop, is almost identical with the one at upper right, installed in 1892 at the O. D. Castle Brothers jewelry shop in Correctionville, Iowa. The clock below it still stands on a New York City street, but the shop or service it once symbolized has vanished.

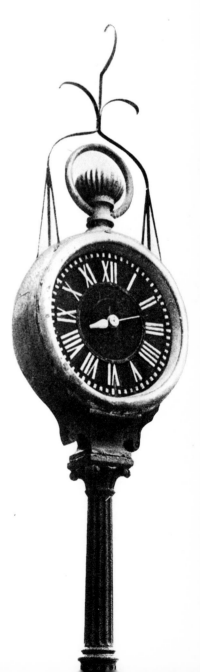

use the same symbol but color it differently. Some tradesmen, particularly tavern- and innkeepers, chose as their symbols figures that had nothing to do with the particular service but had a strong decorative or figurative appeal—a leaping deer or a dancing fox or a flying swan.

Trade signs of varying excellence were in use outside colonial American shops from earliest days. Wooden spectacles, fish, scissors, and bunches of grapes heralded the goods that could be found within. Other services depended for identification on associative forms with generally understood reference—the barber used a striped pole, the druggist a mortar and pestle, the pawnbroker three gold balls. Many trade signs were the crude work

The red-and-white barber pole comes from England, where barbers once provided the blood-letting service which was an important part of medical practice. The spiral red stripes supposedly represent drying bandages. After barbers were barred from surgical activity by order of Henry VIII, they continued to use the old symbolic trade sign, and the stripes still identify the barber. These photographs show poles still in use in the American West in the late 1930s. Because red-and-white striping led to association with the national flag, the color blue is introduced into most of the designs, and one of these poles even features stars. The illuminated pole at left was photographed in Starkweather, N. Dak. At right are four more unusual wooden poles from Williston, N. Dak., Belle Fourche, S. Dak., Yates Center, Kans. (top, left to right), and Muskogee, Okla. (bottom left). The two illuminated poles are from Plentywood, Mont.

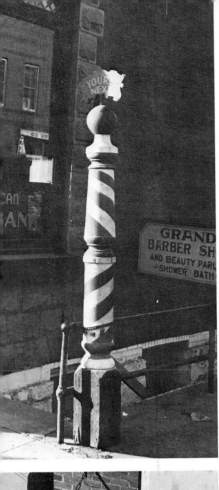

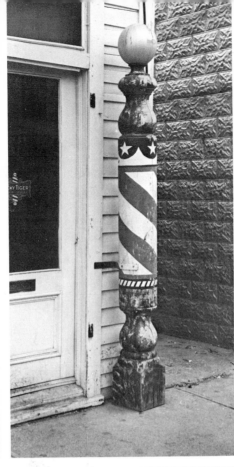

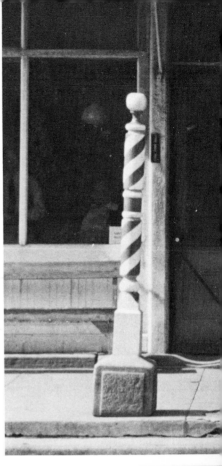

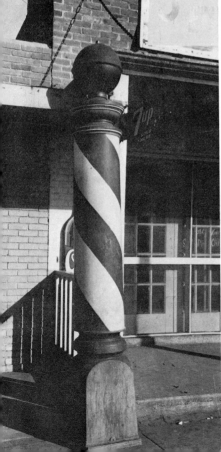

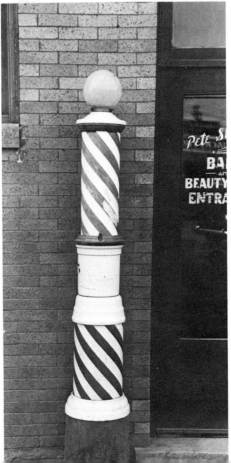

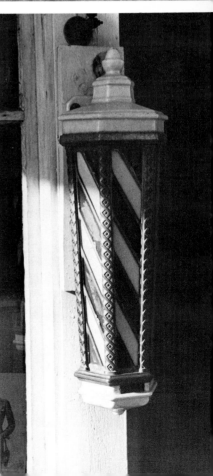

The symbolism of the three trade signs on this page is well known, their origins less so. All were recently photographed—the barber's and pawn-broker's signs in New York City by Mark Feldstein and Emily Wasserman, the druggist's sign in Buffalo by the author. The traditional mortar-and-pestle of the drugstore signifies the making of pills and potions still practiced—at least to some extent—by the modern pharmacist. The pawnshop trademark of three golden balls has a much more complex history. It refers to an incident in the life of St. Nicholas of Myra, who helped an impoverished nobleman marry off his three daughters by providing them with dowries in the form of three bags of gold, which the saint tossed over their courtyard wall on three successive nights. Nicholas became the patron saint of the poor, and the three golden balls signify assistance for the needy. He is still very much with us in the figure of modern American generosity known as Santa Claus.

Opposite are two animal forms that recur as trade signs. The horse in front of the Mobilgas Pegasus was advertising Scotch whiskey when Jack Delano photographed him in 1940 in Watertown, Conn., but he came into being as a display rack for a harnessmaker—like the figure below, photographed at the Shelburne Museum in Shelburne, Vt., by Michael Philip Manheim. The fish is by any count the most regularly recurrent trade sign figure. The bright blue and white one at lower right was photographed very recently in Atlantic Highlands, N.J.

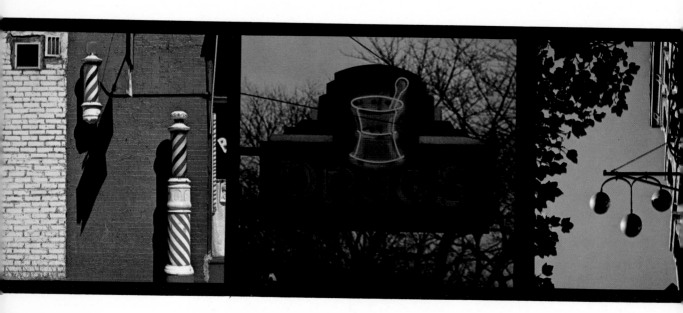

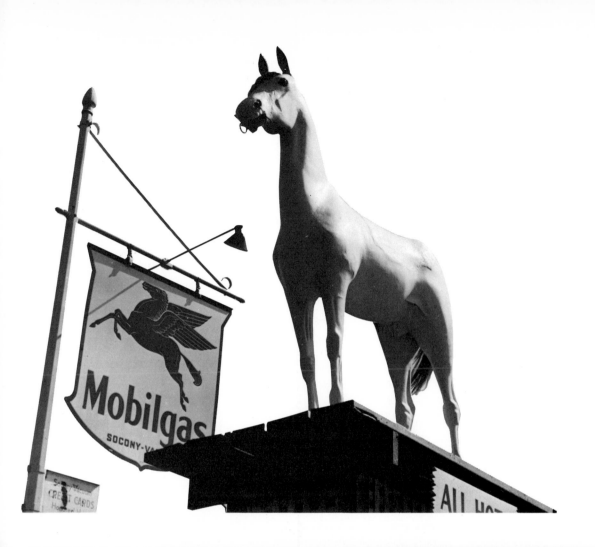

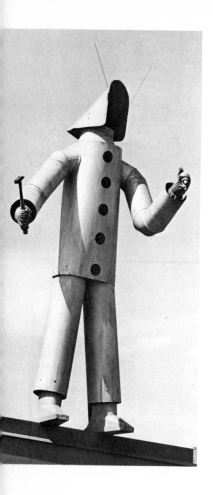

of home craftsmen, but the woodcarvers who were responsible for the heroic Indians also made fine examples of smaller figures to embellish prosperous establishments in flourishing business centers. In the late nineteenth century American iron foundries cast standardized trade signs that had the virtue of durability to offset their weight. Among the most fanciful of American trade signs are the huge robot-like figures that tinsmiths constructed as proof of their versatility.

Intricately carved signs are not commonly met with today, but a few old ones survive and a few new ones continue to be made. Wooden and metal silhouettes are more abundant, but the representational sign that typifies the first half of the twentieth century and remains in great quantity is the one made of neon-illuminated glass tubing.

Neon gas has been known since 1898, when it was discovered and named (*neos* is Greek for *new*) by two English chemists. It probably defied earlier discovery because it is colorless, odorless, and tasteless; but along with such other rare atmospheric gases as argon and helium, neon responds to electricity to form a glowing band between electrodes at either end of a glass tube. The main virtue of neon light is its brilliance. In its pure red illuminated state it is visible for twenty miles. It is also cool, and it is cheap to produce.

The man who adapted neon to general use was a Frenchman, Georges Claude, who first demonstrated the luminous tube in Paris in 1910 and who patented his invention here in 1915. In July 1923 he unveiled his new light to Americans on the billboard of the Cosmopolitan Theatre at New York's Columbus Circle. The attraction it announced was *Little Old New York*. The star was Marion Davies.

The unusual top-hatted and tail-coated tin man opposite, made in a New York City sheet metal shop at the turn of the century, has had wide recognition as a work of art and is now in a private collection. The one at upper left, photographed by Nina Howell Starr above the Western Sheet Metalworks in Anchorage, Alaska, was made in 1960 by Marvin Munger.

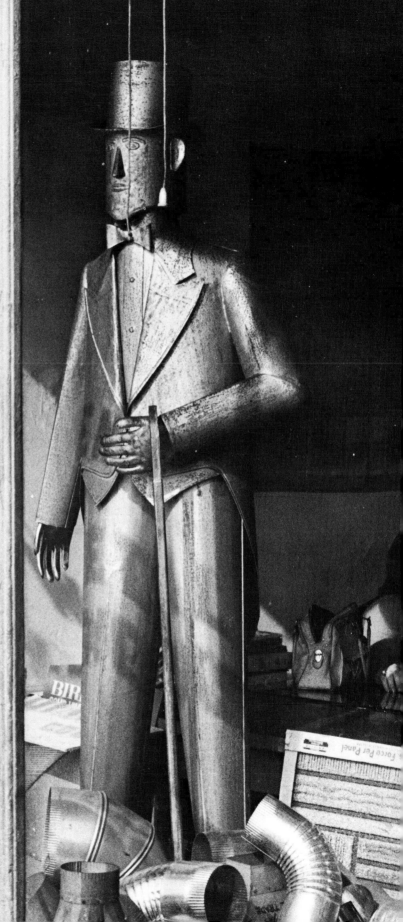

Upholstering

Chairs are rarely represented in neon. This one, at the shop of George Libby on First Avenue in New York City, is doubly unusual in its depiction of a third dimension.

The neon signs on the facing page are currently in use—all in New York City except the locksmith's key and "glasses fitted" sign, which were photographed in Buffalo. They suggest the variety of form in representations of the two most common figures—the shoe and the fish—and they exemplify several other trades that have popular if less frequent representation in neon. All of these figures—shoe, fish, key, eyeglasses, and pawnbroker's symbol—have a long history of trade sign use. In neon tubing, they are just as subject to imaginative interpretation as they were in the wood or metal versions of earlier times.

Both in the United States and in Europe neon signs pointed the way to a new mode of advertising, and they rapidly revamped the appearance of commercial thoroughfares. By 1928 Claude Neon Lights had licensed associates in thirteen major American cities with branches in twenty other locations. By 1929, the year in which the tower of the *New York Times* was identified with huge neon letters, the associates of Claude Neon Lights offered installation and service in almost seven hundred cities.

The reason behind this quickly developed national network was the fragility of glass tubing, which defied long-distance shipment. As a result, neon signs have continued to be bent to shape at local shops, and while the styles of neon letters have been largely standardized, the figures depicted show a remarkable variety of form. What quickly strikes anyone who looks for neon figures, however, is that the images are mostly the same as those which have served as trade identifiers in the past—fish, shoes, eyeglasses, a mortar and pestle for the druggist, a giant key for the locksmith.

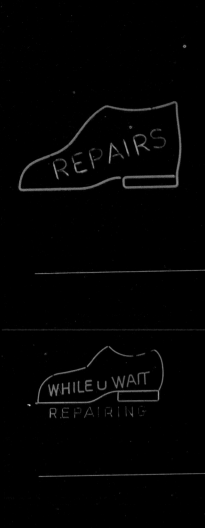

REPAIRS

LOANS

ZWAIL'S

WHILE u WAIT

REPAIRING

LOCKSMITHS

SEA FOOD

ATLAS

REPAIR

SEAFOOD

REPAIR

GLASSES
FITTED

MORRIS & HAROLD

Peter son of
Mr Timothy & Mary
Bancroft died Oct. 26
1786: aged 3 years
4 months &
3 days.

Youth is a fading flower,
And this we often see.
The proof whereof is now
You may behold

Gravestones

To the people of the nineteenth century sculpture meant representation in stone. America had a plentiful supply of skilled woodcarvers who embellished its ships and "chopped" its trade signs, but to begin with it lacked men who were formally trained in the tradition of stone statuary. The first Americans who earned recognition as sculptors were the native sons who went to study in Italy and, for the most part, continued to work there while supplying stone figures for American monuments.

In fact, however, America had had its stonecarvers long before. The Puritans who settled New England may have had a low regard for idolatry and imagery in general, but they made some small exception for the stone slabs that marked their own graves. Carved stone markers have identified grave sites since the time of the Egyptians, and Christians carried on the ancient practice, even borrowing some pagan pictorial symbols for their burial markers. American gravestones were, therefore, the continuation of a well-established tradition. From about 1650 to the end of the

These two New England gravestones of the late eighteenth century, both memorials to children, are as different as they could be. Allan Ludwig's photograph depicts Peter Bancroft as a little gentleman of the post-Revolutionary era. In the Rockingham, Vt., stone above, the deceased infants of Lovita and Elijah Bellows are portrayed as two little sheeplike forms, lambs who had gone astray. The rubbing reproduced here makes the finely incised geometric design much clearer than it is on the original stone. Like the delicate rubbings on the following pages, it was made by Ann Parker and Avon Neal.

45

eighteenth century, New England and the Central Atlantic states were the seat of abundant and highly creative stonecarving activity—but curiously, one that has been all but overlooked until very recently. Many of the stones that commemorate the first settlers have withstood the ravages of time, however, and in their second century of existence they have a good deal to tell us.

The men who made the first New England gravestones appear to have been untrained. The symbols that they carved were, in part, symbols they remembered from English graveyards but more likely were copied from books and prints brought with them. As time went on, the symbols changed somewhat. To begin with they emphasized the grimness of man's fate, later they tended increasingly to reflect the sadness of the mourner.

46

A trumpeting angel floats within a bold proscenium arch to mark the Peterborough, N.H., headstone of Charles Stuart, who died in 1802.

We know the names of several of the early stonecarvers now, and we can identify their work and even trace their styles to apprentices. To some extent, we have been able to reconstruct the geographic area that particular carvers served and to trace the transportation of their completed work along or across convenient waterways. Among the earliest known practitioners were Joseph Lamson of Charlestown, Mass., and William Codner of Boston. The John Stevens family of Newport, R.I., supplied the colonies (and finally the new Republic) with three generations of distinctive carvers. One of New York's most prolific and influential

47

Father Time, the silent reaper, guards a Copps Hill grave in Boston.

A setting sun symbolizes the demise of Capt. Constant Hopkins of Truro, Mass.

Rev. Silas Bigelow of Paxton, Mass., is realistically depicted in his pulpit.

Capt. Lincoln of Hingham, Mass., is portrayed with two wives who predeceased him.

A floral angel declares the mortality of Jedediah Aylesworth of Arlington, Vt.

The angel above the grave of Jonathan Bull of Hartford, Conn., looks surprised.

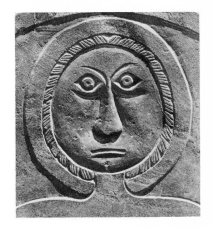

carvers has recently been identified as John Zuricher. A Vermont carver named Zerrubabel Collins has attracted considerable attention for his work as well as his remarkable name.

Since the early 1960s Americans have been studying their seventeenth- and eighteenth-century gravestones with new interest. The growing popularity of gravestone rubbing has helped to trace carving styles and the use of particular symbols. Between the early representations of death's heads and crossbones and the sentimental weeping willows of the nineteenth century, we can identify figures of Father Time, find trumpeting angels who promise resurrection, spot setting suns and broken branches and fallen trees. Among these and other specifically funerary forms are birds and flowers, military insignia, and even some attempts at portraiture.

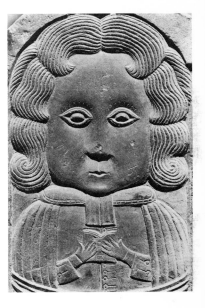

The developing sculptural taste of the nineteenth century finally found its way to the gravestones and put an end to the traditional symbols of the stonecarvers. At the same time, burial customs changed, and the churchyard was replaced by a parklike cemetery. The marble figures, granite slabs, and miniature temples that slowly supplanted thin stone tablets mark another chapter in the history of American art. The first chapter can still be found close by our cities' earliest churches or in the little hill graveyards alongside country roads.

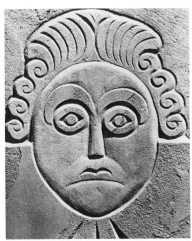

The six rubbings at the left show both realistic and symbolic ways that the dead were memorialized in colonial New England and the young Republic. At right, Allan Ludwig's photographs of gravestone details reveal a variety of carving techniques and illustrate three different ways in which carvers of the same period depicted the human face. The rough-hewn bonneted head uppermost is that of a widow who died in 1761 at the ripe age of 88. Below her is a stone carved more than half a century earlier to mark the grave of an affluent minister. The careful workmanship and highly conventionalized details suggest that the carver had been exposed to formal training in England. The bottom figure, from the late eighteenth century, strikes a midway point that couples technical skill and ambitious design with an altogether original mode of representation.

These decoy drawings, from the Index of American Design, represent three different classes of migrating game birds—shorebird, duck, and goose. All are simplified versions of real birds, with forms and markings reduced to their essentials.

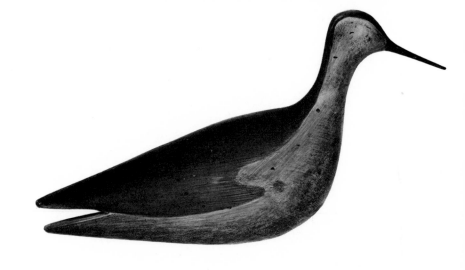

The greater yellowlegs (about 16″ long) and the lesser (about 10″) are among the most elegantly shaped shorebirds. This drawing of a yellowlegs decoy is by Christ Makrenos.

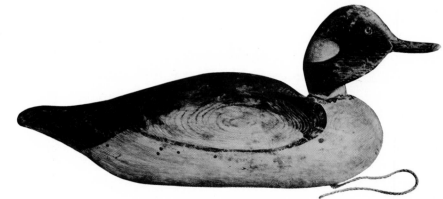

Sea duck decoys, like this one of a bufflehead drawn by Max Fernekes, are carved low and broad-beamed to keep them from upsetting in rough water.

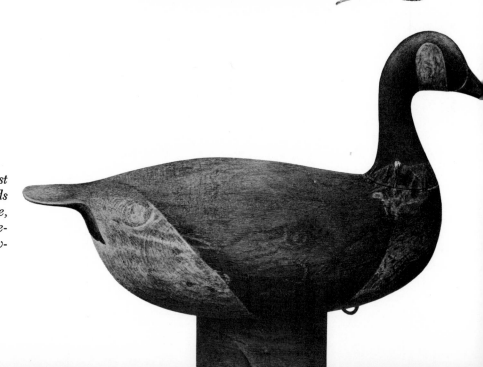

The Canada goose is the most recognizable of the game birds —by virtue of its large size, distinctive markings, and widespread distribution. This drawing is by John Sullivan.

Decoys

In October 1492, eager for signs of land after two months at sea, Christopher Columbus noted in his journal: "All night we heard the birds passing." He did not record what birds they were nor whether his observation helped him deal with the threat of mutiny on the following day. We know, however, that after another two days his expedition reached the Bahamas. From the date and his approximate position at sea, we can conclude that his notation refers to a seasonal migratory flight.

Columbus was, therefore, the first European to observe the mammoth migrations that distinguished the birdlife of the New World. Centuries before his arrival, American Indians had studied the migrations and learned how to take advantage of them as a dependable source of food. The device they contrived to lure the passing birds from the sky and bring them within a hunter's reach was the decoy. We have found Indian decoys almost a

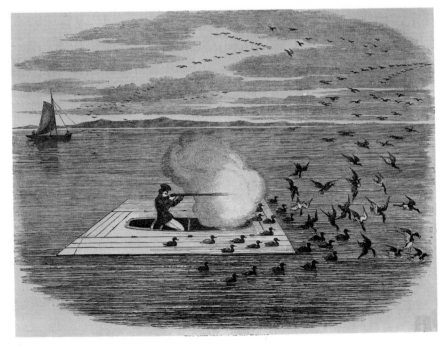

By 1850, when this woodcut of wild duck shooting on the Potomac appeared in the London Illustrated News, Americans were engaged in mass slaughter of game birds for market. The contraption shown here, known as a battery, reportedly enabled the gunner to bring in a daily bag of several hundred. To reach his quarry, he lay flat in a narrow watertight box from which extended canvas wings painted to match the water. Iron decoys were mounted on the wings to keep the rig stable and low as it floated toward a flock of resting birds. Once among them the gunner rose to action.

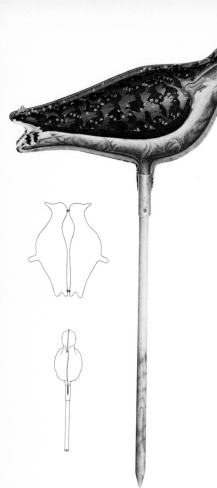

After 1874, folding tin decoys, like this one drawn by Lawrence Flynn, became popular because of their portability. A dozen stamped and painted "tinnies" could be packaged in a box no larger than a single wood decoy. This one represents the golden plover, which once migrated in incalculable numbers. In 1821 John James Audubon estimated that four hundred New Orleans gunners might have destroyed 144,000 in a single day.

thousand years old made of bulrushes and stuffed or painted to look like specific types of birds we can still identify.

In time the settlers who followed Columbus learned to imitate the Indian bird lures. They made decoys of wood and decoys of cork. They made them of dried bird skins stretched over frames, of molded tin, and even of cast iron. They made them to simulate floating waterfowl and wading shorebirds. To begin with, they made them individually, carving and painting each figure to reflect some typical posture or habit. By the latter part of the nineteenth century, however, when gunners were bringing down hundreds of birds daily to supply them to an eager market, decoys were mass-produced at factories that could supply a volume of somewhat less subtle birds to cope with the more common types of migrants.

It is impossible to say how faithful a representation is needed to convince a migratory bird that some of his own kind have found a congenial stopping place and to lure him from the sky. Like fish lures, which span a considerable range between abstraction and realism, some decoys depend on subtle suggestion for effect while others leave no detail of conformation or coloring unportrayed. Collectors have noted identifiable examples of at least twenty different shorebird decoys and over thirty different ducks and geese. In addition to such lures for mass migrants, decoys were made to represent herons, egrets, crows, swans, gulls, loons, flickers, and owls. Some of these last types were used by plumage hunters during the period when fashionable ladies' hats were trimmed with elaborate feather displays. Others were made as "confidence decoys," providing a touch of realistic variety in a group of decoys simulating the hunter's true quarry. Still others

were used as "solitary persuaders"—the sight of a single loon on a remote lake was apparently a symbol of safety that struck a responsive chord in all sorts of migrants.

Commercial hunting slaughtered birds to the point of real or threatened extinction, and some of the great migrations will never be seen again. Public indignation finally produced the Migratory Bird Treaty Act of 1918 which protected North American waterfowl throughout their migratory flight and banned the shooting of shorebirds almost entirely. As thousands of market gunners turned to other occupations, the decoy manufacturers closed up shop, leaving the field temporarily to a few isolated handcraftsmen who continued an exacting art of suggestion and simulation.

Decoys are still in use by licensed hunters shooting in a limited season, but fewer and fewer are the laboriously handcrafted work of the hunter himself or a local wildfowl authority. Once again factory-produced birds without great attention to subtle variation are in service in the field and these molded plastic versions may very well crowd out handmade examples altogether in the long run. Already, the decoys made by America's master carvers—men like Albert Laing of Connecticut, Lothrop Holmes and Elmer Crowell of Massachusetts, and Henry Shourdes of New Jersey— are generally reserved for display by collectors, or museums, or hunters who value them too highly to risk their loss.

Crow decoys, like this one drawn by Roberta Spicer, were once used along the shore as "confidence birds." A passing flock of game birds supposedly reasoned that a beach safe enough for a lone scavenger crow was safe for them. After 1918, crow decoys were used in groups as lures for their own kind—for practice gunning when game birds were out of bounds.

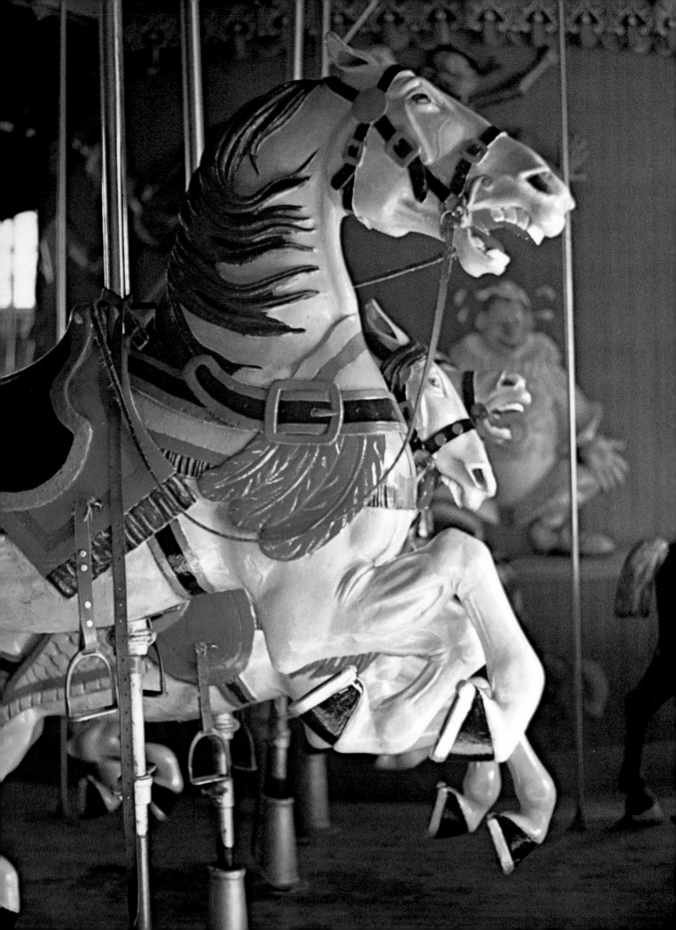

Carousel Figures

Mankind has been spinning in circles from the beginning, of course. We must like the feeling, too. For over a thousand years we have been conscientiously inventing contraptions which would enable us to rotate around a pole for sheer amusement. Most of the early rotating devices suspended a rider from a revolving overhead frame so that he experienced the sensation of flying through space. In days when people were totally earthbound, simulated flight must have had a great attraction, and the rides appear to have been regular features of fairs and carnivals.

In 1784 the New York City Common Council outlawed the use of "flying horses" as "dangerous and improper devices for public amusement" but, as the 1910 advertisement below shows, carousels went on to become a national craze in spite of such prohibitions. The magnificent horses on the facing page were photographed 190 years after the Common Council action—in Central Park.

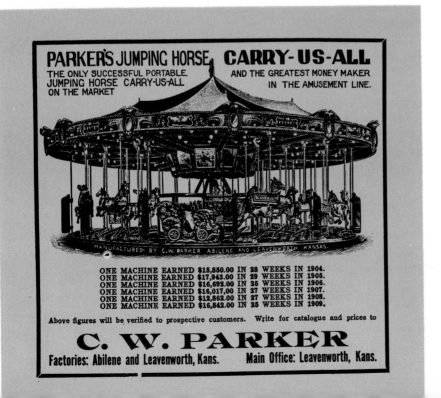

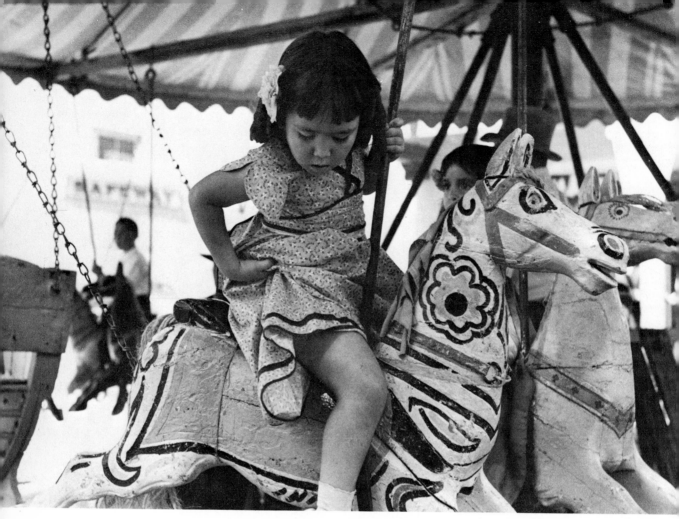

Early carousel horses owe more of their appearance to rocking horses than to live animals. The little girl above, photographed by Russell Lee at a 1940 Taos, N.M., fiesta, rides a horse then identified as one of the oldest in the Southwest. Essentially a toy, it is not unlike the Watch Hill, R.I., flying horse on the facing page or the ponylike prancer below it.

In the eighteenth century the French recognized that the revolving frame had additional possibilities for the sport of ring spearing. This was a test of skill in which a horseman or charioteer tried to capture a suspended ring by passing his lance through it. It was a highly refined art that called for a steady hand, a sharp eye, and a dependable horse. It also called for endless practice. Untold horses were probably worn out in practice sessions before the revolving frame gave the novice a means of perfecting his lancing technique as he circled.

56

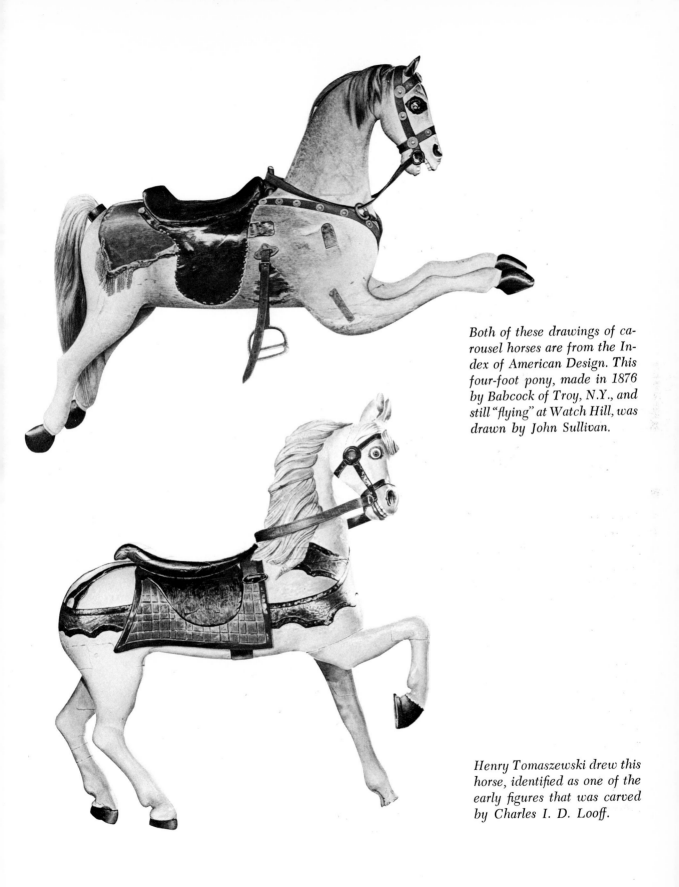

Both of these drawings of carousel horses are from the Index of American Design. This four-foot pony, made in 1876 by Babcock of Troy, N.Y., and still "flying" at Watch Hill, was drawn by John Sullivan.

Henry Tomaszewski drew this horse, identified as one of the early figures that was carved by Charles I. D. Looff.

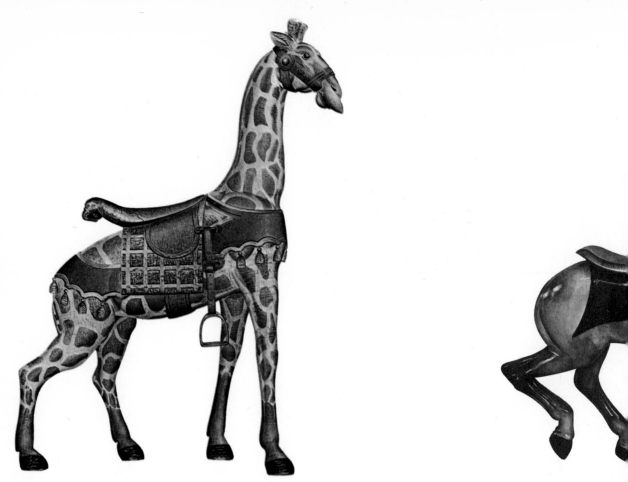

The Index of American Design recorded much of the work that Charles Looff executed for Rhode Island amusement parks —including some of the most delightful of all carousel figures. The Looff giraffe shown here was drawn for the Index by Henry Tomaszewski; the rearing goat by Donald L. Donovan. The horse was drawn by Dorothy Handy; the reindeer by Michael Riccitelli. These late nineteenth-century figures—all about six feet long —are roughly one-third larger than earlier models and considerably more animated in posture.

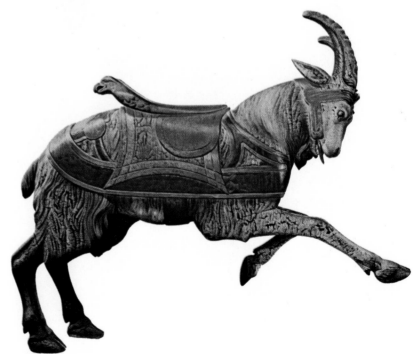

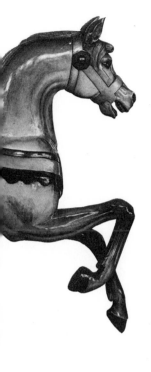

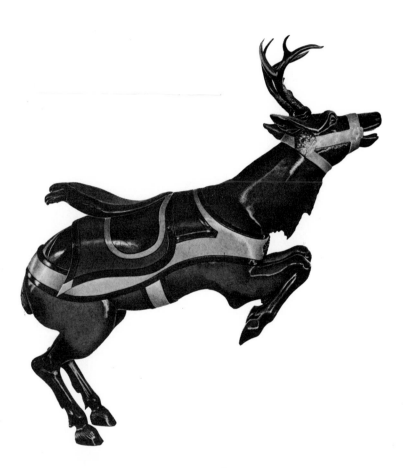

Ring spearing had always been reserved for the aristocrat who had horses to spare. The revolving frame brought it within the reach of the less affluent. For those who were accustomed to travel by foot, however, the dummy horses and fanciful chariots that were contrived to carry the circling lancers undoubtedly had a fascination of their own. Ring spearing finally disappeared as an elegant diversion, but its spirit lives on in the contrivance we know as the carousel and in the rider who wins a free ride for capturing a golden ring.

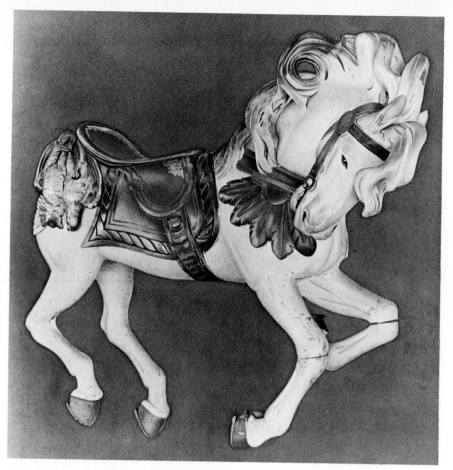

The career of Charles Looff, extending from the post–Civil War period to the beginning of World War I, exemplifies the general development of carousel sculpture. This life-size galloping steed, drawn by Henry Murphy, was probably carved after the turn of the century. It is a long way from Looff's first figures both in the freedom of movement and the splendor of the flowing mane and accessories.

What started the revolving frame toward its ultimate peak of popularity was a power mechanism that could move riders up and down as they circled swiftly in time to the swelling music of a band organ. What fixed its stellar position in America's amusement parks for a period of almost fifty years was a menagerie of gloriously carved beasts and a fleet of ornate chariots that encouraged riders of all ages to let imagination soar as they swept round and round.

Crude carousels of various sorts had been operating in American amusement parks before the outbreak of the Civil War. After hostilities ceased, however, and the country could return to fri-

volity, Gustav Dentzel, a German-born cabinet maker working in Philadelphia, began production of improved models that were well patronized at such nationally celebrated spas as Atlantic City and Cabin John Park on the Potomac River. We know little about the mounts that Dentzel furnished for his riders. From the remains of other early carousels like the one erected at Watch Hill, R.I., in 1876, it appears likely that they were relatively small and toylike—more like hobby-horses than real animals. The work of another early carousel maker, Charles I. D. Looff, who was also a figure carver, is better documented. From 1876 until 1918 he produced a range of animals of every description and a series of horses that progressed from somewhat stiff smiling ponies to highly animated stallions that charged and reared, snorted, gnashed their teeth, and tossed their manes.

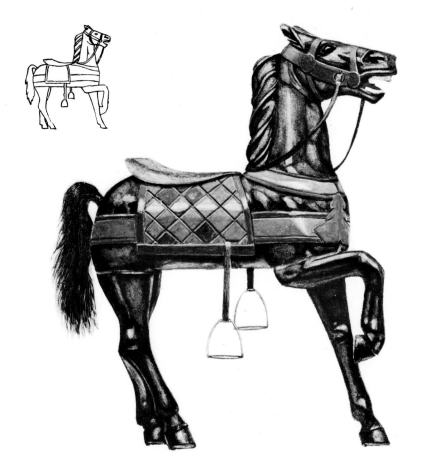

The models that inspired the carvers of the later carousel figures are unknown. Charles Looff might have been thinking of French equestrian statues when he carved his animated horses. Figures from many of the carousels produced by the Herschell-Spillman Company in North Tonawanda, N.Y.—like this smallish one, probably made for a portable unit, drawn by Ernest A. Towers, Jr.—are likely to be less idealized. Sometimes their abruptly frozen posture suggests the cowboy sculpture of Frederic Remington—which, in turn, depended on action photography.

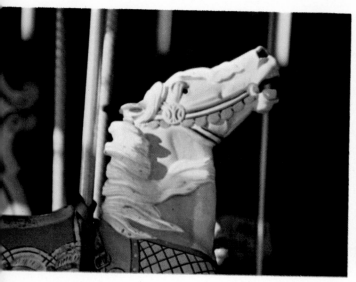
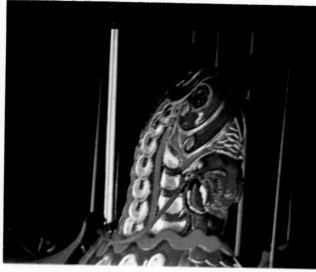

Some of the most magnificent carousels were produced in Brooklyn, N.Y., workshops for use in Coney Island. The figure above, carved after 1910 by Charles Carmel, is still active there. The three somewhat similar figures to the right were carved about the same time in the Brooklyn workshop of Stein and Goldstein for a Coney Island carousel now relocated in Central Park. In some respects, these heads evoke Rosa Bonheur's painting of The Horse Fair, *probably among the most popular works of art of the late nineteenth century. The glorious armored horse was a trademark of Stein and Goldstein carousels.*

The volume of Looff's production is uncertain, but at North Tonawanda, N.Y., the Armitage-Spillman Company (later the Herschell-Spillman Company) was selling over one hundred carousels a year by 1890, and in neighboring Lockport, N.Y., the competing firm of Norman & Evans was producing seventy-five a year by the turn of the century. The Philadelphia Toboggan Company of Chestnut Hill, Pa., alone supplied giant carousels to over one hundred major amusement parks after 1903, and firms like C. W. Parker in Kansas and the American Merry-Go-Round and Novelty Company in the East were selling portable units to countless mobile carnivals and fairs. Horse-drawn merry-go-rounds, not much wider than a panel truck and with as few as six or eight mounts, became a summer feature of city streets.

Carousels are still with us, but in more limited quantities. With every child a prospective car owner, the horse seems to have lost its appeal, and riding a giraffe or a reindeer or sitting in a dragon-guarded chariot no longer fires many imaginations. The wooden figures individually carved for the machines that are left from the carousel's heyday have been replaced in most cases by plastic and metal castings. Some remain though, carefully repainted and repaired after each year of service, still testimony to the most abundant period of life-size animal sculpture the world has ever known.

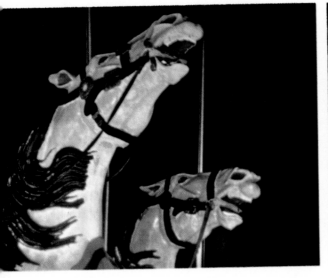
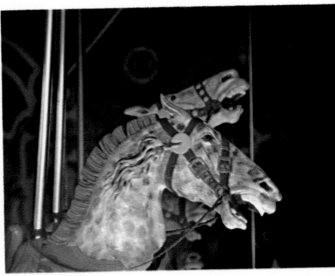

Chariots have persisted from the earliest days of the carousel—as seating for the small or the timid. Some are simply paired benches with painted or carved sideboards, a common motif being a dragon whose arched wings form armrests. Others are horsedrawn carts of imperial splendor, like this silvery one from the Central Park carousel.

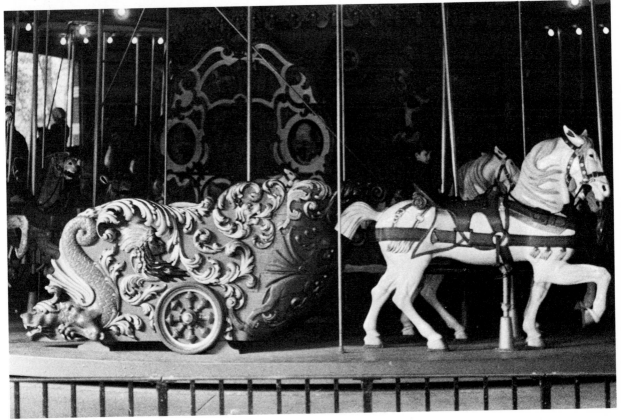

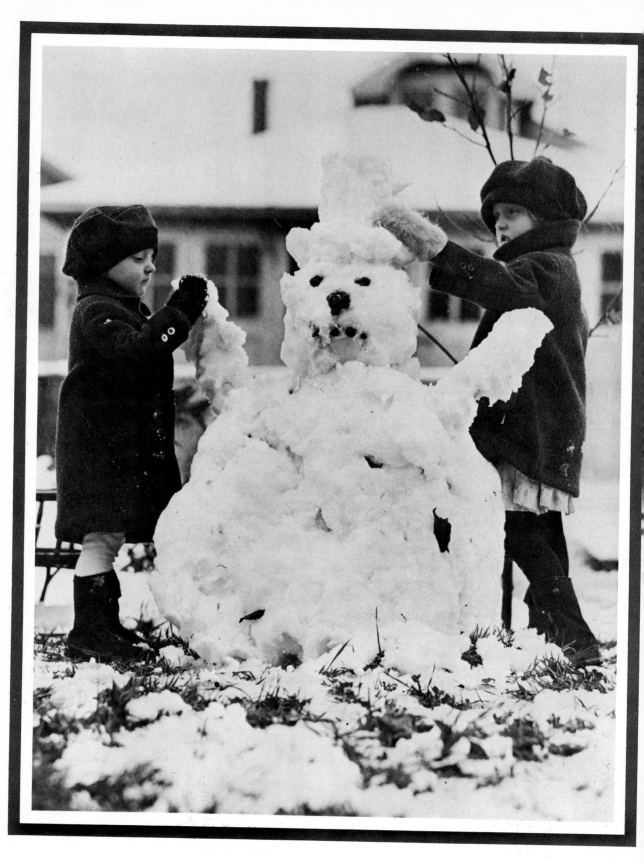

More about Snowmen
...and Scarecrows

Finally, to return to the short-lived figure of the snowman and to his cousin the scarecrow, whose life expectation is only slightly longer. Both are celebrated in our national literature—Nathaniel Hawthorne alone wrote about one in *The Snow-Image* and the other in *Feathertop;* both frequently adhere to a basic construction formula, and both depend on castoffs for their ultimate appearance. There the similarity ends, however. In spite of his fanciful nature, the scarecrow is a product of need. With few exceptions, snowmen meet no need beyond the creative urge to make something out of abundant and malleable snow.

One historic exception to this distinction took place early in the French and Indian Wars, when English soldiers assigned to guard the stockade at Schenectady, N.Y., built snowmen at the gates and relaxed from duty. The Algonquin attack that followed stands as one of the bloodiest American frontier episodes. The design of the snowmen is unrecorded. It seems safe to say that they wore the uniforms of the English militia, but regardless of what materials served as facial features they failed to deceive the enemy.

Whether the Indians were familiar with snowmen is also unknown, although in most moderately snowy climates the figure seems to have developed naturally from the available material. There are national differences to be observed. Nineteenth-century French and German snowmen wore willow baskets as hats. Moundlike Japanese snowmen wear the conical hat of a field-worker. Apparently, superabundance of snow stills the creative impulse; snowmen are unknown in the Arctic.

The fanciful snowman above with the improbably huge carrot nose appeared in the New York Post *in 1882. The slap-dash figure with coal-lump features opposite is from a 1929 Chicago newspaper.*

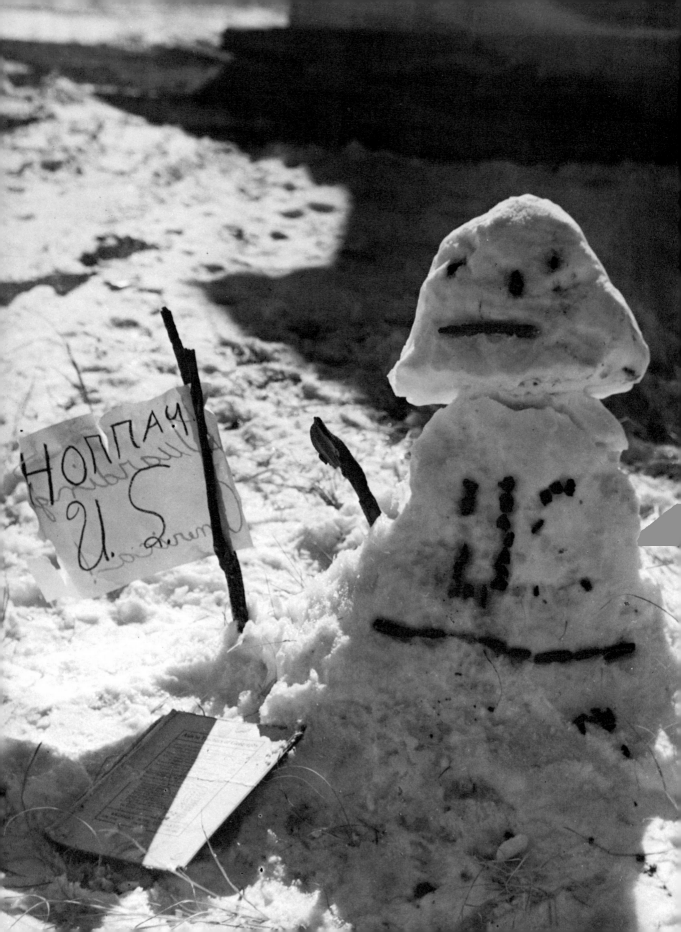

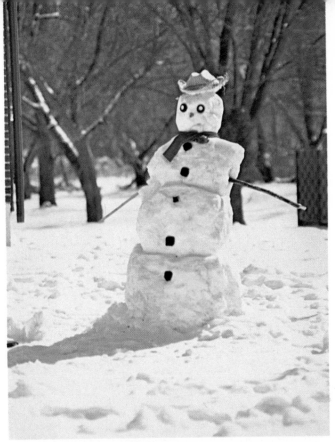

John Vachon photographed the firm-jawed figure on the facing page outside a North Dakota schoolhouse in February 1942, two months after Pearl Harbor. The "Horray U.S." banner proclaims on the reverse that he is "Guarding America!" The lumps of coal used to form the "U.S." on his chest were soon to be in short supply; more prophetic is the abandoned book beside him, titled Aids to Teachers of Geography.

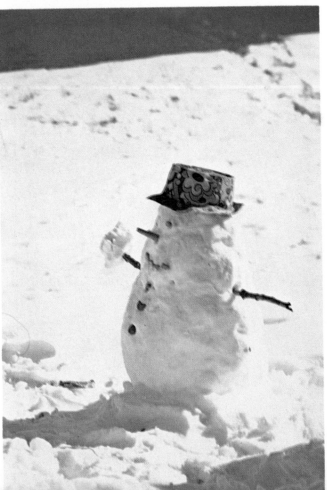

The two less fearsome snowmen on this page were photographed very recently in New York State's Southern Tier. The upper figure, from Tioga Center, has model truck-wheel eyes; the lower, from Painted Post, is all carrots for features. Both sport unseasonable hats, maybe in honor of a February thaw; both have charcoal briquets, a predictable modern substitute for coal, as buttons.

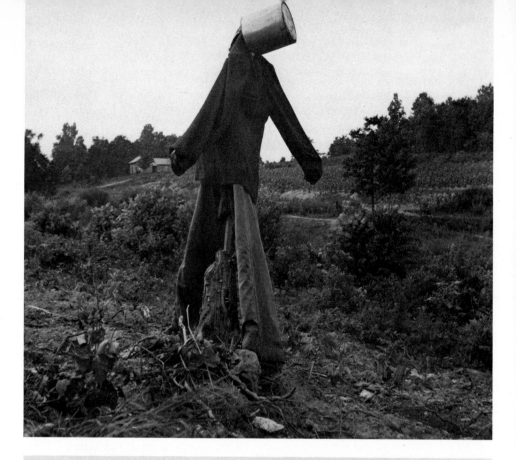

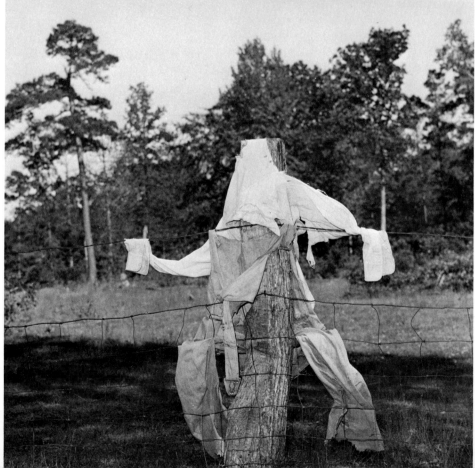

The scarecrow as we know him is also a familiar figure in both Europe and Japan. When the American Indian farmed he depended on somewhat different devices to ward off winged marauders. One sixteenth-century engraving of an Indian cornfield in Virginia shows that a live man was assigned the job of scarecrow and provided with a sheltered platform from which he could threaten approaching birds. Elsewhere, Indians dangled loosely tied bulrushes from stakes to flicker and clatter in the breeze very much as some gardeners would use rags and aluminum strips today.

These three Depression scarecrows of the 1930s exhibit inventiveness in the face of acute clothing scarcity. Dorothea Lange recorded the riddled bucket for a hat in North Carolina; Russell Lee photographed the ripped work clothes draped on a wire fence in Texas; and John Vachon found the ominous if tattered cornfield guardian in Irwin County, Ga.

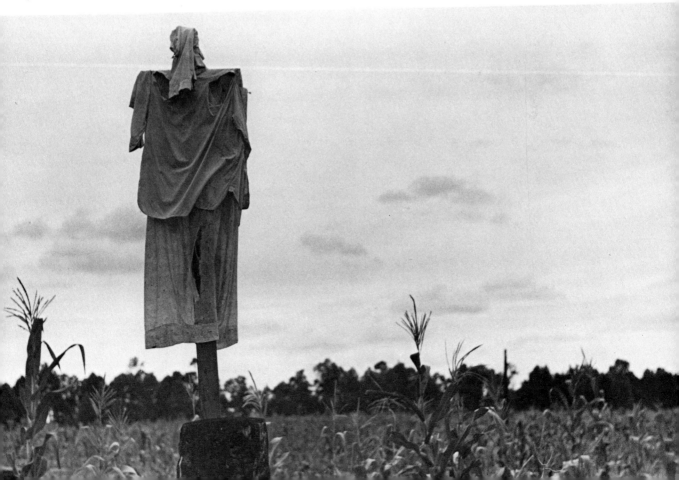

The American scarecrow that developed in the nineteenth century to be celebrated by L. Frank Baum in *The Wonderful Wizard of Oz* is therefore a European import. His basic frame is a simple wooden cross, with the bar located to approximate the shoulder height of a human being. The clothing that is draped over this armature is completely unstandardized today, but earlier scarecrows traditionally wore the gentleman's fancy dress of a previous period. Like the snowman's top hat, the scarecrow's clothes were drawn from an attic supply of coats and pants still serviceable because of infrequent use but possibly discolored from age and always hopelessly out of fashion. When filled out with hay according to nineteenth-century custom scarecrows tended to look like raffish dandies. A traditional American joke has the tramp compare his own worn clothes with those of the scarecrow and decide in favor of a trade.

It is easy to conclude from the appearance of early female scarecrows—who wore the everyday poke bonnet and long cotton dress of the working farmwife—that women were more reluctant to consign their own superannuated finery to the fields than to face the fact that their farmer husbands disliked fancy dress. From the growing number of modern female scarecrows you might come to believe that the woman is a more common gardener today than in the past, that birds are more fearful of women, that women are less zealous of their clothing than they once were, or that it is easier and more pleasurably creative to make a symbolic representation of the traditionally skirted and hatted woman's figure than to make a man's.

I am inclined to favor the last two of these explanations and to look at scarecrows—along with snowmen, decoys, weathervanes, whirligigs, pavement lids, carousel figures, and trade signs—as examples of creative sculpture that can tell a great deal about the time and place in which they were made and about the men and women who made them.

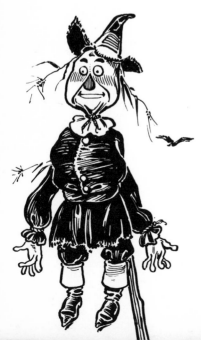

The Wizard of Oz scarecrow as originally drawn by William Wallace Denslow may have intimidated the crows of 1900, but it surely lacks the mysterious persuasion of the six-armed figure at right, photographed by Ann Parker in the late 1960s.

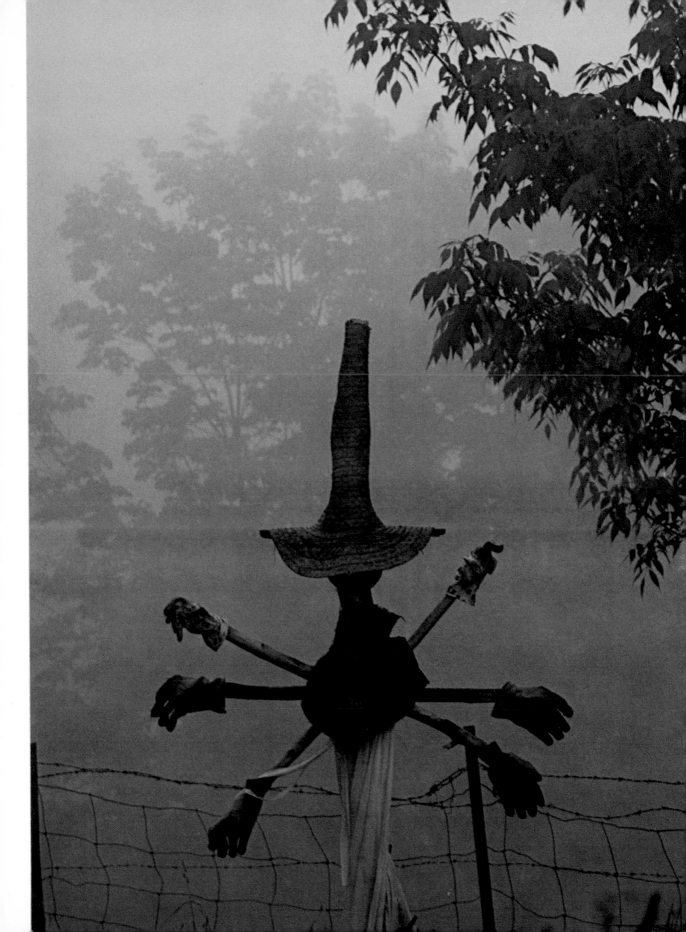

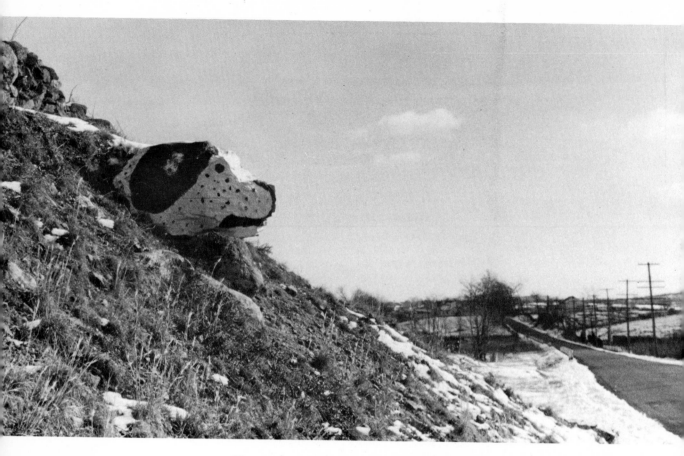

There is no telling where or how the creative urge will surface. This watch-dog, whose appearance is a bone of contention in the town of Preston, Conn., has been part of the local landscape since 1935, when Stanley Zictorac recognized the potential of a natural stone outcropping. Five years later Jack Delano recorded the resulting monument for the Farm Security Administration in this photograph—included here as a reminder that there are countless examples of such "natural" folk sculpture lurking at the roadside.